THEIR GLORY
SHALL NOT BE
BLOTTED OUT

The Frontispiece

His Majesty King George V is shown wearing the uniform of a Field Marshal. The head-dress is a cocked hat, with drooping white swan feathers, ten inches long, with red feathers beneath. The collar, cuffs, sleeve flaps and skirt flaps of the tunic are ornamented with an oak-leaf pattern in gold embroidery. The shoulder cords are plaited, with an aiguillette on the right shoulder. The sash, around the waist, is gold and crimson net with two crimson stripes and loose bullion tassels. With the uniform are worn white leather pantaloons and patent leather jackboots. The sword has a mameluke hilt with ivory grips and a scimitar blade, suspended from gold laced slings backed with red leather.

The horse furniture consists of a blue saddle cloth edged with gold lace, with the Field Marshal's badges of rank in gold and silver embroidery in the corners. The headstall and bridoon rein are of gold lace on red Morocco leather, and the collar chain is of gilt, as are the square set stirrups.

His Majesty is shown carrying the Field Marshal's baton which is covered with crimson velvet and ornamented in gilt. The King is wearing the ribbon of the Order of the Garter, with the stars of that Order and the Order of the Bath on the left breast. At his neck are the badges of the Order of the Bath and the Royal Victorian Order. His medals consist of the badges of the other Orders of Chivalry, with Coronation and Jubilee medals.

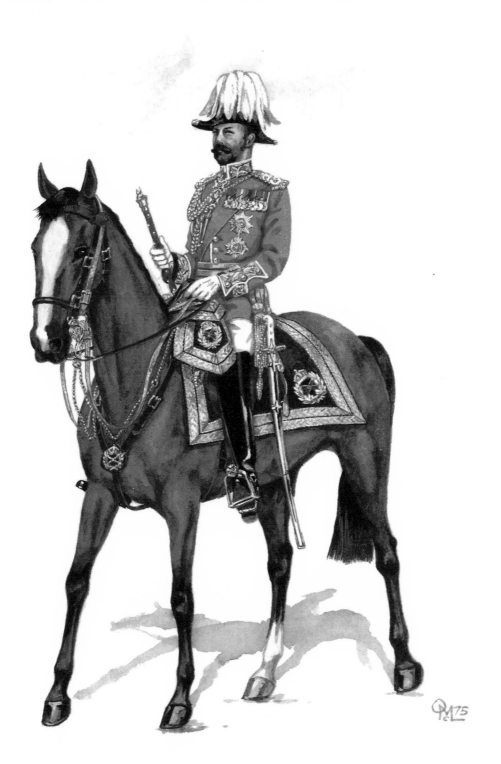

THEIR GLORY SHALL NOT BE BLOTTED OUT

The Last Full Dress Uniform of the British Army

Lieutenant-Colonel Olaf MacLeod

late Coke's Rifles, Frontier Force, Indian Army

Lutterworth Press – Cambridge

**To the Memory
of
The British Army of 1914**

*Their seed shall remain for ever: and their
glory shall not be blotted out. Their bodies
are buried in peace: but their name liveth
for ever more.*

Ecclesiasticus XLIV vv 13–4

**Lutterworth Press
7 All Saints' Passage
Cambridge CB2 3LS**

British Library Cataloguing in Publication Data
MacLeod, Olaf
 Their glory shall not be blotted out: the
 last full dress uniform of the British Army.
 1. Great Britain. *Army* – Uniform – History
 I. Title
 355.1′4′0941 UC485.G7

ISBN 0-7188-2673-6

First Published 1986

Typeset in Monophoto Bembo by
Vision Typesetting, Manchester

Printed in Great Britain by
Jolly & Barber Ltd
Rugby Warwickshire

Contents

List of Plates

Foreword

by
The Rt. Hon. Earl of Cromartie, M.C., T.D., F.S.A. (Scotland)

It is a great privilege to have been asked by my old and valued friend Olaf MacLeod to write an introduction to his book.

As his near neighbour I have been able to see Colonel MacLeod's meticulous and beautiful paintings one by one, and I am sure my admiration for the accuracy of the detail as well as his skill as an artist will be shared by all who read this book.

At a time of stringency and change in so many spheres, much of the elaboration and tradition of service uniforms has gone. The Army is indeed fortunate to have this permanent record available, and to have it so perfectly executed.

I commend this book to you with great pleasure.

Castle Leod,
Strathpeffer,
Ross-shire.

CROMARTIE.

January 1981.

Introduction

When the British Army mobilized for war in August 1914 the full dress uniforms which had been worn for ceremonial duties and walking out were packed away in depots and stores, never again to be generally issued. Ceremonial dress was restored to the regiments of the Household Cavalry and Foot Guards after the Great War, and the musicians of the rest of the Army gradually adopted the old uniforms. From time to time, too, soldiers appeared in full dress in Tattoos and other military displays, the clothing being released from stores for the purpose. Although full dress was not officially abolished between the two World Wars, and new Dress Regulations for officers, including full dress, were actually issued in 1934, the uniforms were never again taken into general use. The new Regulations stated that full dress for the time being was applicable only to the Household Cavalry and Foot Guards, and to officers specially authorized by the War Office, although officers in possession of the full dress uniform of their rank were permitted to wear it at levées.

After the Second World War, the Household troops were again allowed to wear what they term 'Home Service Clothing', and notwithstanding the partial issue of a new Number 1 Dress, the bands in other regiments and corps have again adopted the old full dress, with some modifications. But the new Number 1 Dress did not come into general use and the British Army as a whole has reverted to the khaki service dress of 1914 for ceremonial purposes, albeit with coloured forage caps and some special belts and other accoutrements.

It follows therefore that the year 1914 marked the disappearance from the British scene of the colourful uniforms which had distinguished the regiments of the Army for some three hundred years. Whereas in former days members of the public could recognize a man's unit, or at least his branch of the service, from his dress, a knowledge of full dress today is largely confined to the individual enthusiast. The study of uniform covers a number of stages in the evolution of the Army's dress but the purpose of this book is to record something of the final phase of its more elaborate forms. Major changes in style took place after the Crimean war, when the coatee was replaced by a tunic, and in the years that followed there were many modifications in detail to the patterns introduced at that time. Most of these alterations had taken place by the beginning of the 20th century and, so far as the Army as a whole was concerned, by 1914 the story had come to an end.

As full dress was not officially abolished after the Great War, some new uniforms were authorized in the period between the wars, these being chiefly for officers. To complete the picture a section has been included to illustrate these additions.

The plates, in which the figures are described from left to right, have been designed to show groups of uniforms of similar pattern but differing within regiments. The figures include officers, non-commissioned officers, private soldiers and musicians, and in some cases show back views.

To avoid too much repetition, not every regiment has been included, but the uniforms depicted have all been chosen to show some special distinction or difference within a group. The notes accompanying each plate explain these points and give historical origins where these have seemed appropriate. The titles are those of 1914 and the medals shown are those which might reasonably have been earned by the member of the regiment concerned.

In search of accuracy, many sources of information have been consulted and a great debt of gratitude is owed to all those regimental representatives and museum staffs who have given their time to answer a host of queries. A list of acknowledgements together with a bibliography will be found at the end of the book. A glossary of terms has also been included for those who are not familiar with the terminology of military uniforms.

There are however many pitfalls for the military artist in depicting military dress. The records of some details are scanty and unfortunately those who wore the pre-1914 full dress are sadly few. Memories, too, of seventy years ago tend to fade. Furthermore, regimental customs of wearing certain articles are not necessarily dealt with in Dress Regulations and may even not be in accordance with them. There are for example differences in the wearing of collar badges by Hussar and Lancer regiments, although those badges were authorized at the beginning of the 1900s, the badges being worn in some regiments and not in others.

It is possible therefore that there may still be errors in the plates and if so perhaps these may be forgiven. But it is hoped that the drawings will provide, within the covers of a single book, a reasonably accurate and comprehensive record of the last of the British Army's full dress.

The Author's share of the proceeds from the sale of this book are being donated to the Regimental funds, Queen's Own Highlanders (Seaforth and Camerons).

Jamestown,
Strathpeffer,
Ross-shire.

Olaf MacLeod

March 1986

Acknowledgements

The author is greatly indebted to the Viscount Gough (late Irish Guards), Major John Whitelaw (late Seaforth Highlanders), and Captain Michael Moore, O.B.E. (late King's Royal Hussars) who individually and collectively raised the funds which made publication possible and handled the financial arrangements involved. He also gratefully acknowledges the services of Mr. and Mrs. Robert Yeatman of Colt Books Ltd, who gave much valuable advice. He would further express his gratitude to the Earl of Cromartie, M.C., T.D. (late Seaforth Highlanders) for kindly writing the foreword; to Lieutenant-General Sir George Gordon-Lennox, K.C.B., C.V.O., D.S.O. (late Grenadier Guards) and the late Major-General Goff Hamilton, C.B., C.B.E., D.S.O. (late Queen Victoria's Own Corps of Guides, Frontier Force, Indian Army) for their help and encouragement; and to William Y. Carman Esq. F.S.A., F.R.Hist.S. for his interest and advice. Finally he would mention the late James Heggie Dixon without whose inspiration this project would not have been undertaken.

Over the period from 1975 to 1982 during which research was carried out the following Regimental representatives were extremely helpful in supplying information, for which the author is most grateful.

Lieutenant-Colonel D. Meakin Corporal-Major C. Frearson	The Household Cavalry Museum
Major G. Allsop M.B.E.	1st The Queen's Own Dragoon Guards (2nd Dragoon Guards) (Queen's Bays)
Major F. H. Robson	5th Royal Inniskilling Dragoon Guards (5th Princess Charlotte of Wales's Dragoon Guards)
Captain C. Boardman	3rd Dragoon Guards (Carabiniers) (6th Dragoon Guards)

Major W. J. Haynes	The Royal Scots Dragoon Guards (Carabiniers and Greys) (Royal Scots Greys)
Lieutenant-Colonel P. K. Upton	The Royal Hussars (Prince of Wales's) (10th and 11th Hussars)
Major J. S. Sutherland M.B.E.	The Queen's Own Hussars (3rd The King's Hussars)
Lieutenant-Colonel J. R. Palmer	13th/18th Royal Hussars (Queen Mary's Own)
Major B. O. Simmonds	15th/19th The King's Royal Hussars
P. Russell-Jones Esq.	City of Manchester Art Galleries (14th King's Hussars)
Captain R. C. Peaper	9th/12th Royal Lancers (Prince of Wales's)
Lieutenant-Colonel R. A. Bowman	16th/5th The Queen's Royal Lancers
Lieutenant-Colonel R. L. C. Tamplin	17th/21st Lancers
Captain W. J. Chandler Captain E. Woodford	17th Lancers (Duke of Cambridge's Own)
Major R. G. Bartelot Brigadier R. J. Lewenden S. C. Walters Esq.	Royal Artillery Institution
L. E. Fuchter Esq.	Royal Engineers Museum
Colonel D. V. Fanshawe O.B.E. Major P. A. J. Wright	1st or Grenadier Regiment of Foot Guards
Major J. R. Innes	Coldstream Guards
Major J. F. Warren	Scots Guards
Major R. J. S. Bullock-Webster Major W. W. Mahon	Irish Guards
Major J. L. Goodridge M.A.	Welsh Guards
Colonel B. A. Fargus O.B.E.	The Royal Scots (The Royal Regiment)
Major H. C. L. Tennent	Queen's Own Buffs (The Buffs, East Kent Regiment)
Lieutenant-Colonel R. M. Pratt D.S.O., D.L.	The Royal Northumberland Fusiliers
Brigadier F. M. De Butts C.M.G., O.B.E.	The Somerset Light Infantry
Major T. P. Shaw M.B.E.	Royal Regiment of Fusiliers (Lancashire Fusiliers)

Major D. I. A. Mack	The Royal Highland Fusiliers (Princess Margaret's Glasgow and Ayrshire Regiment The Royal Scots Fusiliers and the Highland Light Infantry)
Major E. L. Kirby M.C., T.D., D.L.	The Royal Welch Fusiliers
Lieutenant-Colonel D. C. R. Ward	The King's Own Scottish Borderers
Brigadier D. B. Riddell-Webster	The Cameronians (Scottish Rifles)
Major S. Tipping	The Queen's Lancashire Regiment (The East Lancashire Regiment)
Major M. K. Beadle M.B.E.	The Staffordshire Regiment (Prince of Wales's)
Colonel The Hon. W.D. Arbuthnot M.B.E.	The Black Watch (Royal Highland Regiment)
Lieutenant-Colonel J. D. Ricketts D.S.O.	The Worcestershire and Sherwood Forester Regiment (Sherwood Foresters, Notts and Derbyshire Regiment)
Colonel J. R. Baker M.C.	The Royal Green Jackets (60th King's Royal Rifle Corps and the Rifle Brigade)
Lieutenant-Colonel A. A. Fairrie	Queen's Own Highlanders (Seaforth and Cameron Highlanders)
Major G. Morrison D.S.O. Captain K. I. H. Lumsden of Banchory	The Gordon Highlanders
Lieutenant-Colonel W. R. H. Charley J.P.	Royal Irish Rangers (Royal Irish Rifles)
Major G. A. N. Boyne J.P.	Royal Irish Fusiliers
Lieutenant-Colonel G. P. Wood M.C.	The Argyll and Sutherland Highlanders
Sergeant J. E. McPhail	Headquarters, The King's Division
Major C. W. P. Coan	Royal Army Service Corps
Colonel D. A. Tennuci	Royal Army Medical Corps
Lieutenant-Colonel D. A. Dickson Major L. J. Taylor M.B.E. Captain I. O. Robertson	Royal Corps of Signals
Colonel P. H. Hordern D.S.O., O.B.E. Major S. C. Doble	Royal Tank Regiment
Lieutenant-Colonel R. C. Jacob	Ministry of Defence
A. F. H. Bowden Esq. Peter Hayes Esq. S. C. Wood Esq.	National Army Museum

Colonel P. S. Newton M.B.E. Army Museums Ogilby Trust
Major N. P. Dawnay

W. Boag Esq. Scottish United Services Museum
W. A. Thorburn Esq.

E. C. Joslin Esq. Spink and Sons, Medallists

NOTE

Since 1914 some of the regiments illustrated have disappeared or have had their titles changed as a result of re-organization. The present day titles of the descendants of those units, who have supplied information, are therefore given in the above list, with the designations of the relevant regiments of 1914 in brackets.

General Officers wore a cocked hat similar to that of a Field Marshal. The tunic similarly had gold embroidery in an oak-leaf design on the collar, cuffs, sleeve flaps and skirts, and plaited gold shoulder cords. The sash, too, was the same as a Field Marshal's. The pantaloons were of blue cloth with scarlet stripes $2\frac{1}{4}$ inches wide and with the pantaloons were worn knee boots. The sword and slings were the same as a Field Marshal's. The horse furniture consisted of a blue saddle cloth edged with gold lace, with the General's badges of rank embroidered in the corners.

The Colonel in the undress uniform of a frock coat, worn on formal occasions when full dress was not ordered, has a cocked hat similar to that of a general officer but with plumes only eight inches long. The sash also is the same as a General's but the shoulder cords on the frock coat are the universal pattern twisted cord. Colonels on the staff wore the staff aiguillette in gold and crimson orris cord on the left shoulder. In dismounted order overalls with Wellington boots and box spurs were worn, the overalls having scarlet stripes $1\frac{3}{4}$ inches wide. The sword carried by Colonels was the same pattern as that in the branch of the service to which the Colonel formerly belonged. The officer in undress wears the Infantry pattern sword.

The Colonel in full dress, dismounted, wears a tunic the collar, cuffs, sleeve flaps and skirt flaps of which are ornamented with bands of gold lace. The shoulder cords again are the universal pattern. The officer carries the Cavalry pattern sword which was introduced in 1912.

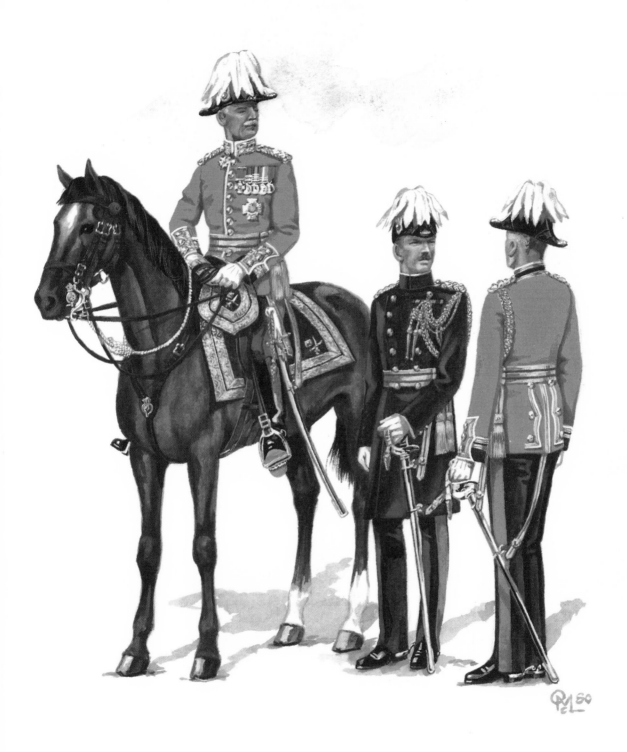

General Officer and Colonels on the Staff

1
The Household Cavalry

THE HOUSEHOLD CAVALRY

In 1914 the Household Cavalry consisted of the 1st and 2nd Life Guards and the Royal Horse Guards (The Blues). The full dress uniform of all three regiments was similar, the Life Guards wearing scarlet tunics and plumes of white horsehair, and the Royal Horse Guards having blue tunics and red plumes, originally made of yak hair.

The Mounted Review Order of all three regiments included some features peculiar to the Household Cavalry, namely the cuirass, introduced at the coronation of King George IV, and the jackboots with white buckskin pantaloons, which date from 1812. The helmets, which were the choice of Prince Albert, came into use in 1842. A further distinction is the gold aiguillette suspended from a heavy gold shoulder cord. This aiguillette is worn by officers on the right shoulder and by non-commissioned officers on the left. The aiguillette replaces the usual rank chevrons worn by regiments of the Line and varies according to rank. Apart from the colours of tunics and plumes, there were other minor differences between the regiments, as illustrated in the drawings. Most of the details of the Household Cavalry uniforms have been retained until the present day, although some of the distinctions of the 2nd Life Guards disappeared on their amalgamation with the 1st Life Guards after the Great War.

*T*he trooper shows the difference between the shape of the plumes of the Royal Horse Guards and the Life Guards. The hair of the former hangs straight whereas in the Life Guards the hair is kept tied near the dome when not in use, a procedure which results in the 'onion' shape at the top of the plume. The trooper also wears the chin chain on the point of the chin, the Life Guards wearing their chains below the lower lip.

The mounted officer shows the rounded corners of the shabraque of the 2nd Life Guards, the corners being pointed in the 1st Regiment. The saddle cover is of white sheepskin, those of the 1st Life Guards being of black bearskin. Another difference between the two regiments was the colour of the flask cord on the cartouche belt, the 1st having red and the 2nd blue cords. The cuirass was edged with blue velvet and the bridoon rein in the Life Guards was gold lace on red leather.

The dismounted officer shows the additional band of gold embroidery round the top of the collar and cuffs of a field officer's tunic. In Levée dress the cuirass was not worn. Both officers carry the State sword peculiar to the Household Cavalry which has a plated hilt and scabbard, ornamented with brass mounts. The sword knots of all three regiments have bullion tassels, but the straps were different, 1st Life Guards having a white leather strap and the other two regiments having embroidered crimson leather straps.

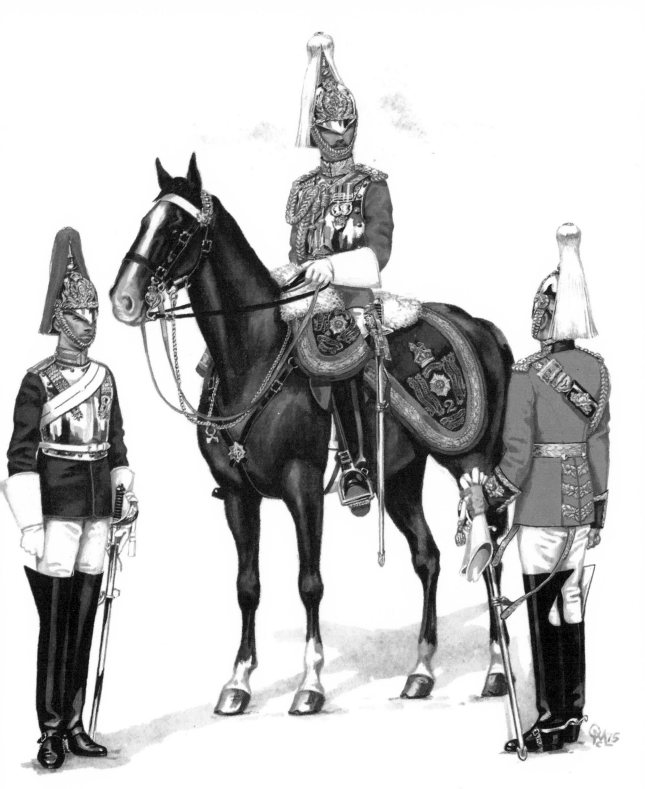

Trooper – Royal Horse Guards, Mounted Review Order
Officer – 2nd Life Guards, Mounted Review Order
Officer – 1st Life Guards, Levée Dress

The mounted officer of the Blues wears the distinction lace of a field officer, similar to that of the Life Guards officer in Plate 2. The shabraque in the Royal Horse Guards is scarlet, with pointed hind corners, and the saddle cover is of black lambskin. Unlike that of the Life Guards, the bridoon rein is of black leather, as is the rest of the headstall. The ends of the scales on the cuirass are of special pattern, different from those of the Life Guards, and the cuirass is edged with red velvet. The gold laced cartouche belt has a central stripe of scarlet, and a crimson flask cord, and the sword slings also have a central scarlet stripe.

The Corporal of Horse (the equivalent of a sergeant in the Cavalry of the Line) wears dismounted review order with which the cuirass is not worn, and overalls with Wellington boots replace the white leather pantaloons and jackboots. This N.C.O. wears the second class aiguillette which has no coils above the trophy tags. Corporal Majors wore the first class aiguillette, which like the officers' pattern had these coils. In the 2nd Life Guards the stripes on the overalls were double $1\frac{1}{4}$ inches wide, with a scarlet welt between, while the 1st had double scarlet stripes $1\frac{1}{2}$ inches wide and no welt. The former pattern is now worn by the amalgamated Regiment of Life Guards.

The officer of the Royal Horse Guards shows the undress frock coat, which was similar in all three regiments of Household Cavalry but there were differences in the complicated figured braiding which ornamented the collars and cuffs. In this order of dress the sword belt, slings and sword knot are of white buff leather. The overalls of the Blues have single scarlet stripes $2\frac{3}{4}$ inches wide. The forage caps of all three regiments again were similar but with different embroidery on the peaks.

The figure of this officer shows a cap badge but the badge was not taken into wear until after the Great War, although the other ranks wore bronze badges on their service dress caps in 1914. The precursor of the officer's badge was that worn by officers of the Household battalion, a special unit raised within the Household Cavalry in 1916 and trained as infantry.

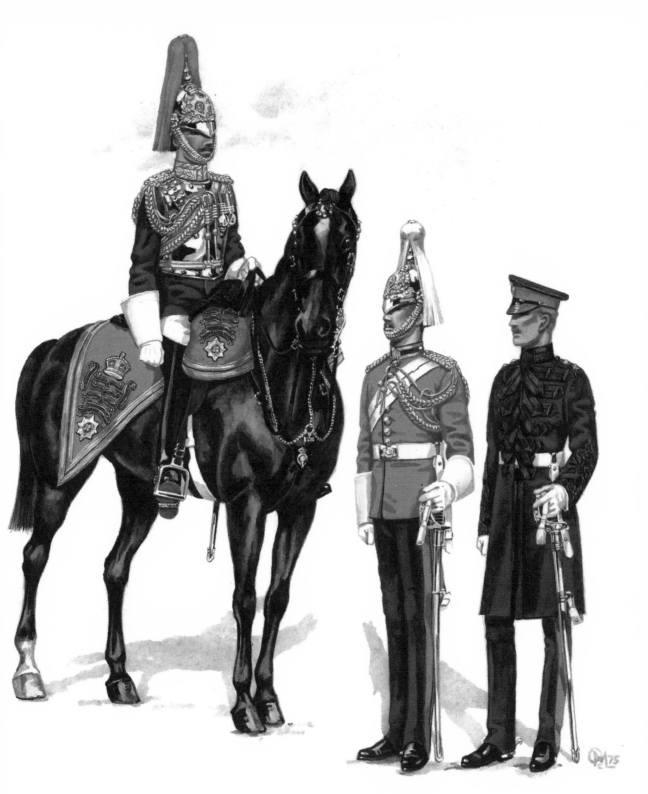

Officer – Royal Horse Guards, Mounted Review Order
Corporal of Horse – 2nd Life Guards, Dismounted Review Order
Officer – Royal Horse Guards, Undress Frock Coat

The trumpeter in State dress shows the State coat worn by all musicians of the Household Cavalry on State occasions and in the presence of the Royal family. The coat is made of crimson velvet, heavily braided with gold lace. On the breast and back there is the Crown and cypher of the reigning sovereign, in this case that of King George V. A special gold laced sword belt is worn in this order of dress, with which are worn white buckskin pantaloons and jackboots. The head-dress for all musicians in State dress is the blue velvet riding cap.

The Farrier Corporal of Horse of the 1st Life Guards wears a blue instead of a scarlet tunic, as did all farriers of the Life Guards, and his plume is black instead of white but still has the 'onion' shape at the top. The cuirass is not worn by farriers in the Household Cavalry and instead of the usual white cartouche belt worn by other ranks a ceremonial axe belt is worn, with a flask cord appropriate to the regiment. The axe belt has a frog at the back for carrying the axe on the march.

The trumpeter of the 2nd Life Guards illustrates the mounted Review Order of all musicians in the Household Cavalry, the tunics of the Royal Horse Guards of course being blue and their plumes red. In the Life Guards the musicians' plumes are also red. The cuirass is not worn by musicians. The tunic has gold piping down the fronts and round the bottom of the skirts, with gold braid round the top and bottom of the collar inside which there is a trimming of 'bullet hole' braid. Musicians have gold shoulder cords instead of the gold edged cloth shoulder straps worn by troopers. This order of dress is also worn by dismounted sentries and N.C.O.s on duty with the Sovereign's Life Guard at Whitehall in London, and is designated 'Front Yard Order'. The trumpet banner is crimson silk heavily embroidered with the Royal Arms and other devices, and the cords and tassels are crimson and gold.

The dismounted figures show the State sword of other ranks in the Household Cavalry. The sword is of the sabre type with a plated scabbard and hilt and a white leather sword knot.

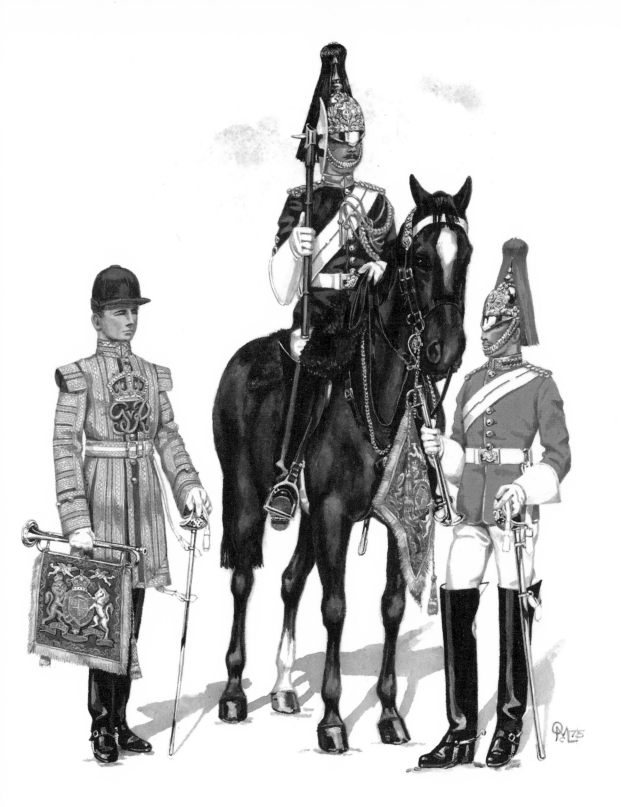

Trumpeter – Household Cavalry, State Dress
Farrier Corporal of Horse – 1st Life Guards, Mounted Review Order
Trumpeter – 2nd Life Guards, Mounted Review Order

2
The Cavalry of the Line

THE DRAGOON GUARDS AND DRAGOONS

The regiments of Dragoon Guards and Dragoons (the former heavy cavalry of the Army), with one exception, wore scarlet tunics, and blue pantaloons or overalls with a single broad stripe. The head-dress, again with one exception, was a metal helmet with a horsehair plume. The regiments were distinguished by the colours of their facings and plumes.

THE HUSSARS

The uniform of the Hussar regiments is Hungarian in origin, the heavily braided tunic and fur busby with its 'bag' having been copied from the dress of the Hungarian Hussars in the Continental armies of the period of the Napoleonic wars. The British Hussars came into being in 1806 when some of the Light Dragoon regiments were so equipped and re-named. The regiments were distinguished by the colour of their busby-bags and plumes, with other differences as illustrated in the plates.

THE LANCERS

The uniform of the Lancer regiments was not introduced in the British Army until 1816 when it was decided to arm some of the Light Dragoon regiments with the lance. The features of the dress were copied from the Lancer regiments of the Polish army and included the double breasted tunic with plastron fronts, and the unique square-topped cap known as a 'chapka'. The regiments were distinguished by the colour of their facings and plumes.

The sergeant wears the standard other ranks' tunic, edged down the fronts with the colour of the facings, and having 'Austrian' knots in yellow cord above the cuffs. An arm badge, worn by all sergeants, is shown above the rank chevrons, this in the 3rd being the Prince of Wales's feathers. The helmet is brass, those of the officers being of gilt metal. The sergeant wears a white buff leather shoulder belt (as do some of the other figures in the Cavalry section plates). This article was withdrawn, except for trumpeters and bandsmen, in the early 1900s. The officer of the Queen's Bays is mounted on a horse of that colour, as were all ranks of the regiment. An officer's tunic was ornamented round the top of the collar with gold lace, the 'Austrian' knots and shoulder cords also being gold. The girdle, shoulder belt and sword slings were gold laced and edged with the colour of the facings. In the Bays, the facings although described as buff were in fact nearly white. The single stripes on the pantaloons were white, the other regiments having yellow. The lambskin worn over the saddle was edged with the colour of the facings except in the 1st Dragoon Guards which had a red edging.

The officer of the 6th Dragoon Guards shows the exception among Dragoon Guards in that he wears a blue tunic. The origin of this dates from 1851 when the 6th were ordered to be clothed as light cavalry prior to being posted to India. The posting was later cancelled but the change in dress went ahead. The double white stripes on the overalls, and the pickers and chains on the shoulder belt are light cavalry features which were retained. The tunic in this regiment was edged with gold cord down the fronts and round the skirts.

The bandsman of the 5th Dragoon Guards shows the 'Austrian' knot above the cuff. The bandsman also wears the yellow cord aiguillette which was a distinction worn by all musicians in the Dragoon Guards and Dragoons. Musicians frequently wore plumes of a different colour from those of the remaining ranks. In this case the plume shown is that authorized in 1902, instead of the white outside red horse hair worn by the rest of the regiment.

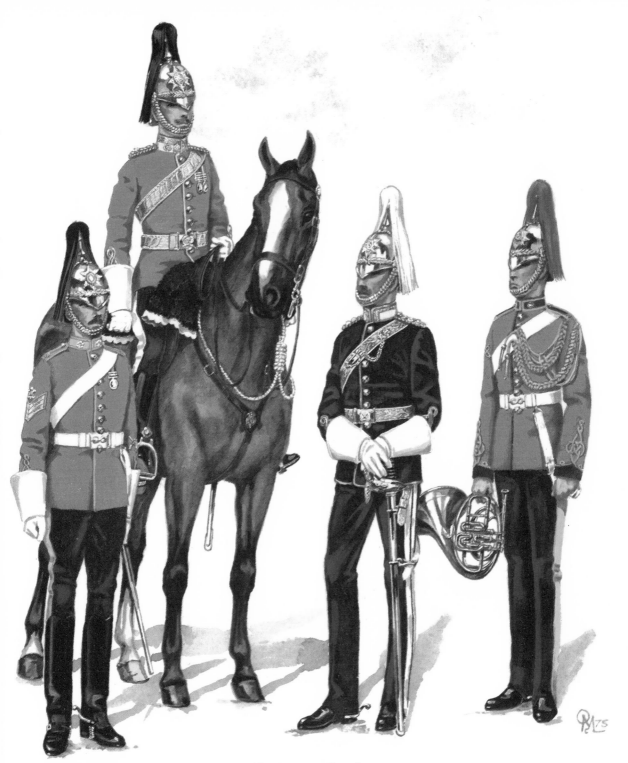

The Dragoon Guards

Sergeant – 3rd (Prince of Wales's) Dragoon Guards

Officer – 2nd Dragoon Guards (Queen's Bays)

Officer – 6th Dragoon Guards (Carabiniers)

Bandsman – 5th (Princess Charlotte of Wales's) Dragoon Guards

*T*he tunics of all Dragoon officers were the same as those of the Dragoon Guards. The officer of the 1st (Royal) Dragoons shows the white metal helmet worn in Dragoon regiments instead of the gilt helmet of the Dragoon Guards. The girdles, sword slings and shoulder belts were gold laced, the officers' sword knots having white straps and gold 'acorns'. The horse furniture included a lambskin with scalloped edging, and a throat plume in a gilt ball socket, the colour of which differed according to regiments.

The Royal Scots Greys were the exception with the bearskin cap, with a white cut feather hackle which was held in a gilt flame socket. The officers' sword knots were of gold cord with a tassel in the form of a thistle, the lace on their belts having a distinctive pattern.

The trumpeter of the Royal Scots Greys wears the distinction, unique to that regiment, of a red hackle which goes right over the top of the bearskin cap. This hackle was worn by all musicians of the Greys. He also wears the musician's yellow cord aiguillette. The trumpet banners of the Greys were of special pattern embroidered with the Royal Arms of Scotland. Trumpeters wore short white gloves instead of the gauntlets of the remaining ranks in Dragoon Guard and Dragoon regiments.

The trooper of the Inniskilling Dragoons illustrates the back view of the other ranks' tunic, which had a three-pointed flap on each side of the centre seam. Officers' tunics had similar flaps edged with gold cord. The trooper is in dismounted full dress in which order overalls and Wellington boots with box spurs were worn instead of pantaloons and knee boots. The other ranks' sword belt and slings were of white buff leather, the shoulder belt having a black leather pouch. The officers' pouches had a silver flap and were ornamented with gold embroidery.

As shown, the colour of the horse-hair plumes was different in each regiment.

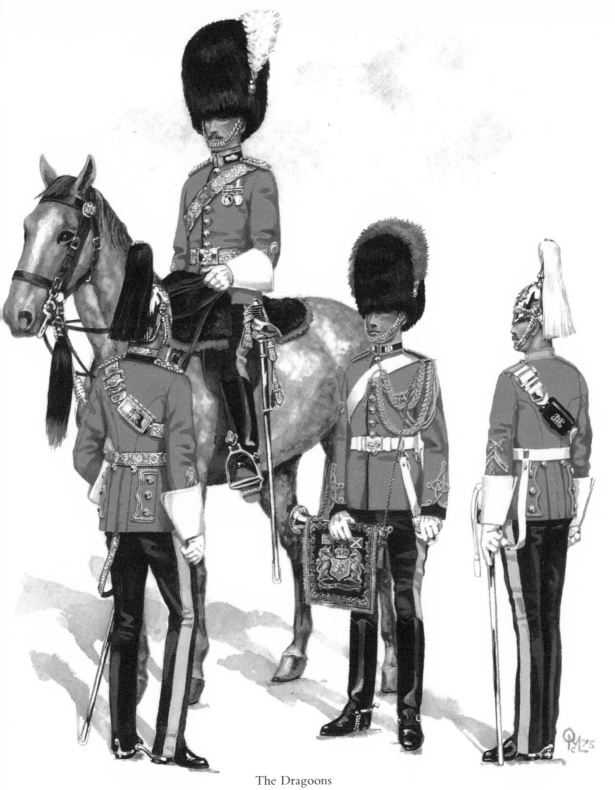

The Dragoons

Officer – 1st (Royal) Dragoons
Officer – 2nd Dragoons (Royal Scots Greys)

Trumpeter – 2nd Dragoons (Royal Scots Greys)

Trooper – 6th (Inniskilling) Dragoons

The collars of tunics in Hussar regiments were the same blue as the tunic except in the 3rd, which had scarlet, and the 13th, which had buff collars, this latter colour being almost white. The sergeant wears the sergeant's arm badge above his chevrons, this being the white horse of Hanover in the 3rd. The plumes of the other ranks were of horse hair, there being variations in the colours of the top and bottom sections.

The mounted officer of the 11th shows that regiment's special distinction of wearing crimson pantaloons instead of the blue in the other regiments. A further distinction was that of plaiting the busby lines on the chest. The officers' horse furniture in the Hussars included a leopard skin saddle cloth edged with the colour of the busby-bag, and a throat plume. The officer's busby plume was of ostrich feathers with a vulture feather bottom, and the knee boots had an oval gold corded boss.

The officer of the 10th Hussars shows the braiding in gold chain gimp on the back of the tunic. The figure also shows the special features of levée dress, in which order the pantaloons had gold braid on the side seams, instead of double cloth stripes, and the Hessian boots, worn with straight necked box spurs instead of knee boots, were edged with gold gimp. The 10th in levée dress were distinguished by their scarlet pantaloons. Their shoulder belts, instead of being gold laced, were of black leather with a gilt chain ornamentation, a feature giving rise to their nickname of 'the Chainy Tenth'. Princes of the Blood serving in the 10th wore a scimitar sword with a mameluke hilt in levée dress, a pattern worn by all officers of the 11th in that dress, but other officers of the 10th carried a sword with a three-bar hilt.

The trumpeter of the 13th Hussars shows the dismounted full dress of other ranks, whose tunics were decorated with yellow cord instead of the officers' gold chain gimp. In this regiment a distinction was the double white stripes, instead of yellow, on the overalls. The cavalry trumpeter carried both the bugle and trumpet, the former being used in the field and the latter in barracks. The bugle- and trumpet-strings are the standard green worn in non-Royal regiments.

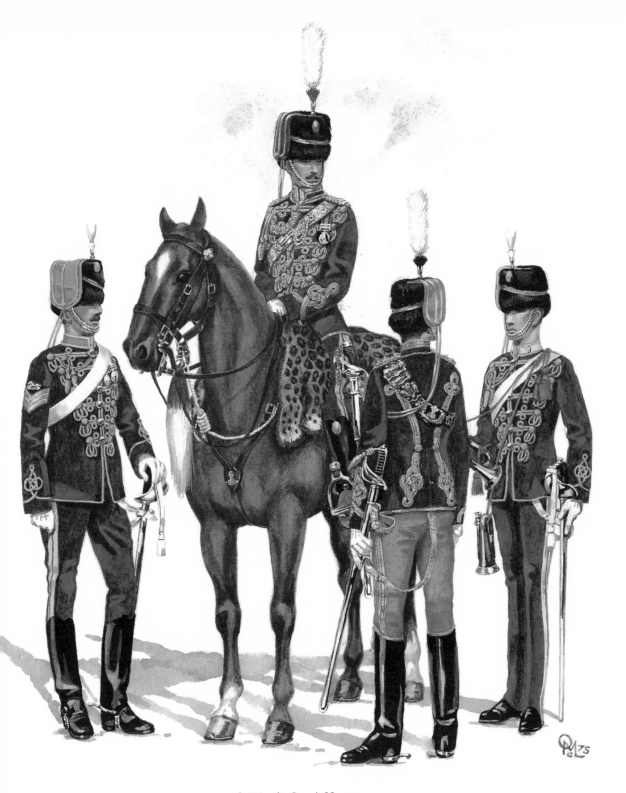

Sergeant – 3rd (King's Own) Hussars
Officer – 11th (Prince Albert's Own) Hussars
Officer – 10th (Prince of Wales's Own Royal) Hussars
Trumpeter – 13th Hussars

T he corporal of the 18th Hussars illustrates the back view of the other ranks' tunic, the braiding being similar to that of an officer but in yellow cord. The blue of the busby bag of the 18th was of a darker shade than the 'Garter' blue of the 3rd, and in this regiment the bottom of the plume was red.

The mounted officer of the 15th Hussars shows a distinction of that regiment in that the busby lines did not encircle the busby three times as in the other regiments. A further distinction was that no pickers and chains were worn on the shoulder belt. On the leopard skin of the 15th there were scarlet patches on the wallet covers on which were embroidered two crossed Bourbon flags, upside down. This device commemorates the battle of Emsdorf in 1760 when the regiment captured five French battalions, with their colours.

The officer of the 19th Hussars again shows the levée dress of Hussar regiments and the Hessian boots worn in this dress instead of knee boots. The shoulder belt of the 19th had a white stripe down the centre (some other regiments also had a central stripe) and the belt was unique in that battle honour scrolls were worn on it, together with the Assaye elephant, a badge gained in India in 1803 at the battle of that name.

The corporal of the 14th Hussars shows a distinction of that regiment in the arm badge worn by all corporals, as well as sergeants of the regiment, above the rank chevrons.

The four figures show the differences in the colour of busby bags and plumes in Hussar regiments.

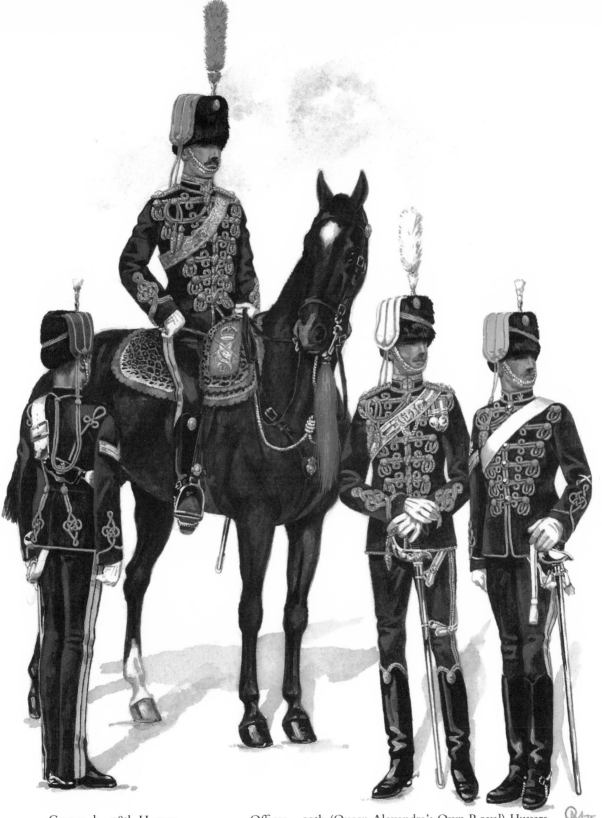

Corporal – 18th Hussars
Officer – 15th (King's) Hussars
Officer – 19th (Queen Alexandra's Own Royal) Hussars
Corporal – 14th (King's) Hussars

The sergeant of the 5th Lancers shows the back view of the other ranks' tunic and in particular the distinctive welts in the colour of the facings in the back seams and in the seams of the sleeves. In Lancer regiments, the sergeant's arm badge, which was the Harp in the 5th, was worn on the centre of the chevrons.

The trumpeter of the 17th shows the method of carrying the trumpet on the back when mounted. The bugle and trumpet strings were red, yellow and blue. The double stripes on the pantaloons were white in the 17th as opposed to the yellow stripes of the other regiments, as was the Lancer plastron of the tunic.

The officer of the 9th Lancers illustrates the special pattern of chapka in that regiment. The top of the head-dress was covered with black patent leather, like the skull, instead of in cloth of the facing colour, as in the other regiments. The peak also was different being bound in gilt metal and there was gilt metal on the corners of the top instead of gold embroidery and gold cord. The Lancer cap was attached to the body by lines, gold for officers and yellow cord for the other ranks, which encircled the body and were looped on the left breast. Lancer regiments wore a girdle instead of a sword belt, the officers' pattern being of gold with two crimson stripes while the other ranks had yellow.

The three figures illustrate the difference between the officers' and the other ranks' plumes. The former were of drooping swan feathers, 14 inches long, those of the other ranks being shorter and made of horse hair. The colours of the plumes distinguished the regiments.

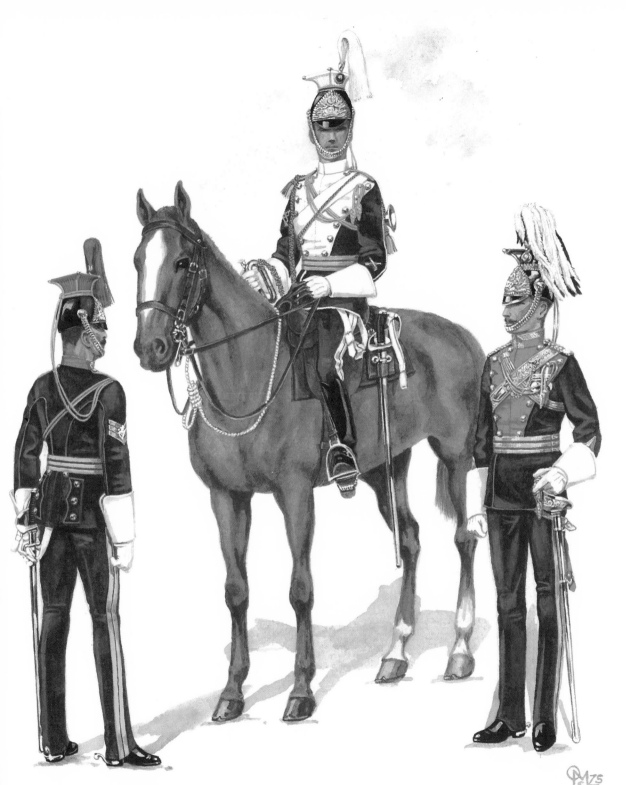

Sergeant – 5th (Royal Irish) Lancers
Trumpeter – 17th (Duke of Cambridge's Own) Lancers
Officer – 9th (Queen's Royal) Lancers

*T*he mounted officer of the 21st Lancers shows the lambskin saddle cloth, edged with the facing colour, which was part of the horse furniture of all Lancer officers. In the 21st, the stirrup slides were of a special pattern. The figure also shows the unique French grey of the facings of this regiment.

The officer of the 12th Lancers illustrates the back view of the officers' tunic. In this regiment the officer's pouches were of scarlet leather, the 17th having blue and the 21st black pouches while the remainder had scarlet. The officers' shoulder belts and sword slings, except in the 9th, had a central stripe of the facing colour. The pouch flap in all regiments was silver except in the 9th whose pouch ornaments were of gilt.

The trooper of the 16th Lancers illustrates the dismounted full dress in which order overalls and Wellington boots were worn instead of knee boots and pantaloons. The 16th alone among Light cavalry regiments wore a scarlet tunic, a distinction which has given the regiment the nickname of 'The Scarlet Lancers'. The trooper's lance pennon is crimped, a custom which dates from the battle of Aliwal in 1846, during the Sikh wars in India. The 16th were the first regiment to use the lance in battle in India, and after the battle their pennons were so encrusted with blood that they appeared to have been crimped. The regiment have crimped their pennons ever since.

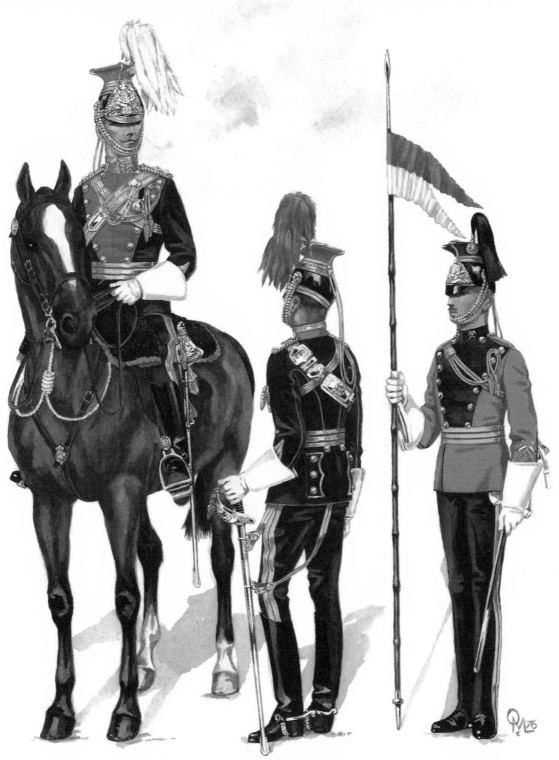

Officer – 21st (Empress of India's) Lancers
Officer – 12th (Prince of Wales's Royal) Lancers
Trooper – 16th (Queen's) Lancers

3
The Royal Artillery

The similarity of the uniforms of the Royal Horse Artillery to that of the Hussars has led to the nickname 'The Four-Wheeled Hussars' but the shell jacket which distinguished the Royal Horse Artillery from the other branches of the Royal Regiment of Artillery is in fact unique, and when an officer or man was posted to a Horse battery he was said to have 'got his jacket'. The head-dress is a fur busby similar to the Hussars' but the busby-bag has no braid and instead of a chin chain there is a black leather chin strap, worn beneath the chin.

The Battery Sergeant-Major's jacket shows the arrangement of the yellow cord on the back seams, the same cord being used for the loops across the fronts. Officers' jackets were trimmed in the same way but with gold cord, the buttons of the Royal Horse Artillery being of ball pattern. The Sergeant-Major wears a crown above his chevrons, with an embroidered gun below the crown. The plume of his busby is of white horse hair.

The officer of the Royal Horse Artillery shows the officer's plume of white ostrich feathers with a vulture feather bottom. The busby lines are shown looped on the left breast, but when the King's Troop was instituted by King George VI after the Second World War he directed that the lines should be looped on the right side, apparently so that the 'acorn' ends of the lines should not get in the way of the wearer's medals. Officers' saddles were covered with a lambskin with an edge of scarlet cloth.

The officer of the Royal Field Artillery shows the tunic worn by officers other than those of the Royal Horse Artillery. The head-dress was the universal cloth helmet, surmounted by a gilt ball in a leaf cup, and having a helmet plate consisting of the Royal Arms with the Artillery Gun below. The gold laced shoulder belt was the same as that of the Royal Horse Artillery but the girdle was unique in that it had a snake hook clasp joining two oval plates each bearing the Royal Arms. The Artillery sword has a half basket hilt and is slightly curved.

The tunic of a bandsman of the Royal Artillery was unique, being ornamented with bars of gold lace traced with braid. The busby plume was red instead of white and a grenade was worn in front. The busby also had a chin chain instead of the leather chin strap of the Royal Horse Artillery busby.

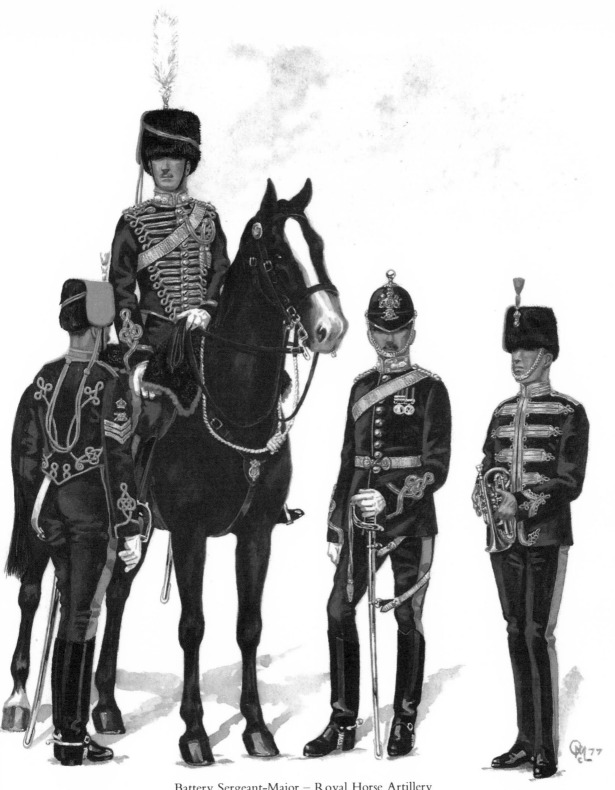

Battery Sergeant-Major – Royal Horse Artillery
Officer – Royal Horse Artillery
Officer – Royal Field Artillery
Bandsman – Royal Artillery

*T*he bombardier (the equivalent of a corporal in other units) wears trousers instead of the overalls with Wellington boots and spurs worn by the rest of the Royal Artillery in dismounted full dress, the Royal Garrison Artillery being a dismounted corps. The rank badge of a bombardier was a single chevron. On the back skirts of the tunic, which was the same as that of the Royal Field Artillery, there were three-pointed flaps edged with yellow cord, and there was scarlet piping on the centre seam. The head-dress was the universal cloth helmet. The bombardier is armed with Short Magazine Lee-Enfield rifle prior to the issue of which the weapon was the Artillery carbine.

The trumpeter of the Royal Field Artillery shows the standard tunic of the other ranks. The trumpeter wears a striped girdle instead of a waistbelt. As in the cavalry, trumpeters of the Royal Artillery carried both the bugle and trumpet, the strings being of red, yellow and blue, the colours peculiar to 'Royal' corps.

The figures of the Royal Engineers show the universal helmet, with a spike on top. The helmet plate was the Royal Arms. The sergeant's tunic shows the back skirts of the special pattern peculiar to the Royal Engineers. Instead of a three-pointed flap on each side there was a pleat edged with blue cloth. Sergeants wore a grenade in gold embroidery above the three rank chevrons.

The officer's tunic in the Royal Engineers had several special features. The facings were of Garter blue velvet, the fronts being edged with the same material and rounded at the bottom. The shoulder cords were treble twisted, with a small 'wing' at the bottom. The officer's shoulder belt had three stripes of gold embroidery on crimson leather, the centre stripe being waved. The sword was the Infantry pattern with a pierced steel guard.

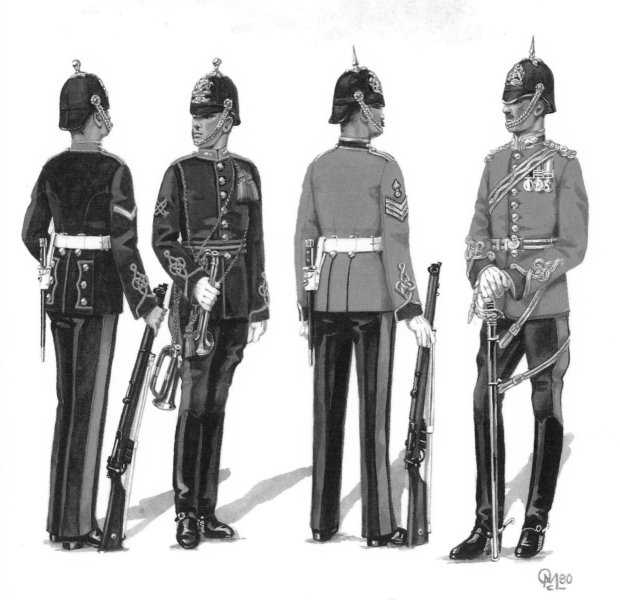

Bombardier – Royal Garrison Artillery
Trumpeter – Royal Field Artillery
Sergeant – Royal Engineers
Officer – Royal Engineers

4
The Foot Guards

In 1914 there were only four regiments of Foot Guards: the Grenadier, Coldstream, Scots and Irish Guards, the Welsh Guards (illustrated in Plate 28) not being raised until 1915. The regiments are distinguished by the grouping of their buttons and by the colour of the plumes in their bearskin caps. In the Guards however there are many variations in the uniforms of the different ranks, and in the articles worn in the different orders of dress, and these are dealt with in the plates.

The tunic of the ensign (the title of a second-lieutenant still retained in the Foot Guards) shows the embroidery on the collar, cuffs, shoulder straps and flaps of an officer below the rank of captain, there being only one row of embroidery on the collar and cuffs and edging to the flaps. The ensign, being in Guard order wears a crimson silk net sash and white buff leather sword slings. He also wears trousers instead of the overalls worn by field officers. The red plume in his bearskin is of cut feathers, the Guardsmen's plumes being of horse hair.

The drum-major of the Scots Guards shows the tunic worn by all drum-majors in Guard order. The bars of gold lace on the fronts and the cuff flaps are arranged according to regimental custom, this being in threes in the Scots Guards. The lace on the sleeves, and the wings on the shoulders, are the distinctions of a drummer, and the drum-major's four rank chevrons are worn on the right sleeve above the flap. The bearskin has no plume in the Scots Guards. The cross belt is embroidered with the regiment's badges and battle honour scrolls.

The mounted officer of the Grenadier Guards shows the additional rows of embroidery on the collar, shoulder straps, sleeve flaps and cuffs on the tunics of the officers of the rank of captain and above. The field officer wears the gold and crimson net sash and gold laced sword slings, with a gold cord sword knot, worn on State occasions. An officer in mounted order wore pantaloons with scarlet stripes and knee boots until 1936 when, by order of King Edward VIII overalls and wellington boots were substituted. The figure's horse is wearing the State Saddlery of an officer of the Grenadier Guards, the saddle cloth being edged with gold lace and a gold fringe. The saddle wallets are covered with a bearskin flounce. In the Grenadiers a gold lace headstall is worn under the bridle and its lace rein is attached to the girth. The regimental badge of a grenade is worn on the face piece of the bridle and on the breastplate. The Grenadier officer's bearskin has a horse-hair plume as opposed to the cut feather plumes of the other regiments.

The officers' swords in the Foot Guards have three-bar hilts and sword knots of gold cord on State occasion, the knots being of white leather with a gold acorn at other times.

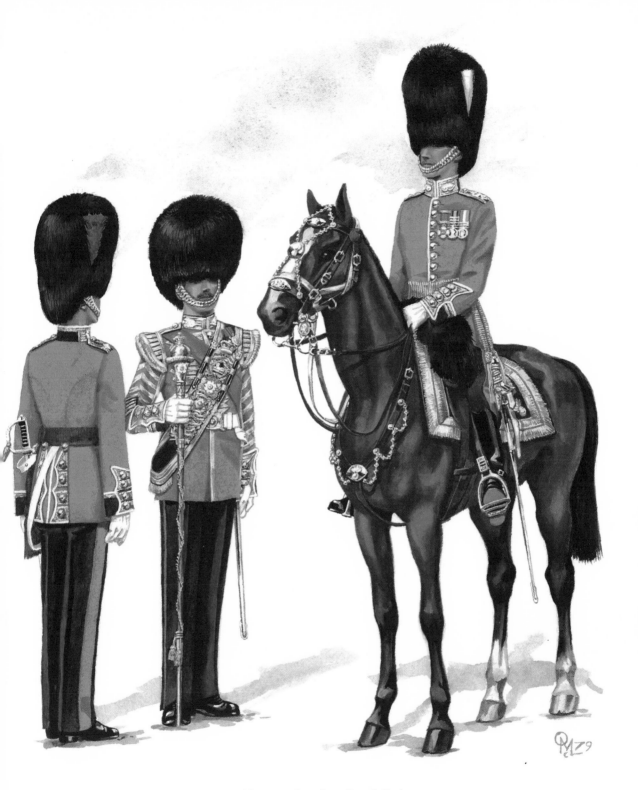

Ensign – Coldstream Guards – Guard Order
Drum-Major – Scots Guards – Guard Order
Field Officer – Grenadier Guards – Mounted Order

The field officer of the Irish Guards shows the overalls worn instead of trousers by officers of that rank, with Wellington boots and box spurs. The buttons are arranged in groups of four, and a small distinction of the Irish Guards is in the embroidery on the sleeves and skirt flaps; next to the buttons the small 'cushion' is in the form of a shamrock trefoil instead of being oval, as in the other regiments. The figure again shows the gold and crimson net State sash. The plume in the bearskin cap is of St. Patrick's blue cut feathers. The choice of St. Patrick's blue rather than green was taken because the Royal Irish Fusiliers, who also wore bearskin caps, had a green plume. In all Foot Guards regiments the spurs are of brass.

The colour-sergeant of the Coldstream Guards illustrates the special tunic of that rank in the Guards, the collar, cuffs and sleeve flaps being ornamented with gold lace. The buttons are arranged in pairs in the Coldstream Guards. The rank badge on the right sleeve is also peculiar to the Guards, the chevrons being much larger than those of sergeants of the Line, and colour-sergeants having a colour and crossed swords embroidered on the chevrons, with a crown above. The bearskin plume is of cut feathers, instead of the horse hair of the guardsmen's plume, but the bearskin is smaller than that of the officers', although larger than a guardsman's. Colour-sergeants of the Battalion staff carry a slung sword; in this case the figure is a Drill Sergeant before the introduction of the rank of Warrant Officer Class II in 1913.

The drum-major of the Grenadier Guards wears a State coat and blue velvet cap similar to that worn by musicians of the Household Cavalry on State occasions, or in the presence of members of the Royal Family. Drum-majors however wear a crimson silk apron with a gold fringe instead of the Cavalry sword belt, and white gaiters with gilt buttons and gold garters instead of jackboots. State dress is the same for all regiments of the Foot Guards, there being differences only in the badges and devices on the apron and sash.

The guardsman of the Scots Guards is in Guard order. In this order of dress, the Atholl grey greatcoat was carried folded on the shoulders attached by straps to the braces of the white buff leather equipment. The grey cape was rolled and carried on the waist belt, as were the two ammunition pouches. The regimental badge on a black ground was worn on the centre strap securing the greatcoat.

In 1936, by command of King Edward VIII, the wearing of the greatcoat was discontinued, the folded cape taking its place on the shoulders. At the same time, ammunition pouches were removed from the waist belt.

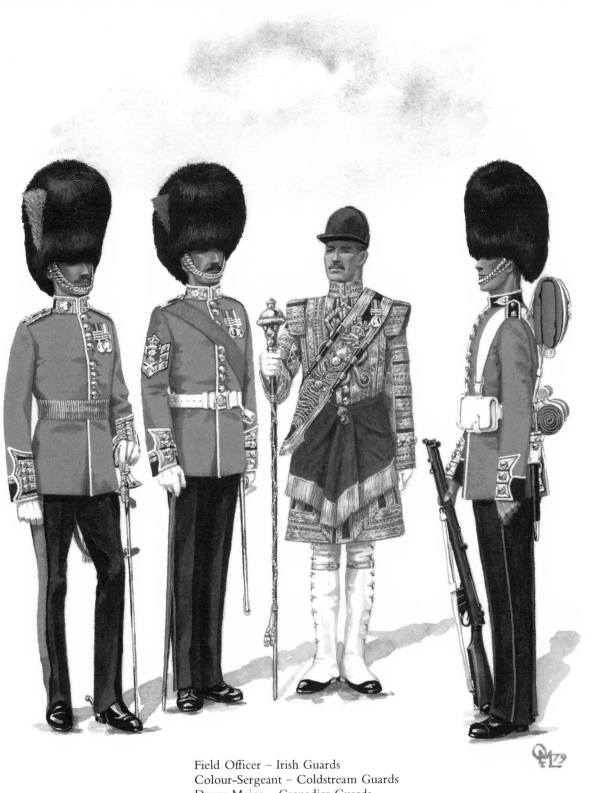

Field Officer – Irish Guards
Colour-Sergeant – Coldstream Guards
Drum–Major – Grenadier Guards
Guardsman – Scots Guards

The drummer's tunic has the white lace, ornamented with blue fleur-de-lys, worn by all drummers in the Guards, the bars of lace being spaced according to custom. A distinction of this regiment is the white cord hoops on the drum, the hoops of the other regiments being the 'Royal' blue. This feature dates from the 18th century but its origins are obscure. Some say that the blue wavy line or 'worm' alludes to the regiment's early history as a unit of the Parliamentary army. The Coldstream was the only regiment of that Army to join the Royalist army of Charles II.

The musician of the Grenadiers illustrates the gold laced tunic of all musicians in the Guards. As in the case of the drummers, the lacing was spaced regimentally, the Grenadiers having single spacing. There was however a difference in the Grenadiers' tunic in that the cuffs were gauntlet shaped with bars of lace instead of the flaps worn in the other regiments. This cuff dates from Hanoverian times, the Grenadier Guards having retained this pattern when the other regiments changed. The musician wears the brass mounted sword with a cross-bar hilt which at one time was the musician's weapon.

The blue doublet of the Pipe-Major of the Scots Guards is trimmed with silver lace and has silver braid loops on the gauntlet cuffs and skirt flaps. The rank chevrons on the right sleeve are also of silver lace. The buttons on the fronts, which are hooked up, are in the groups of three of the Scots Guards. Pipers in the Scots Guards carry the Highland broadsword as well as a silver mounted dirk and sgian dubh. The tartan worn is the Royal Stewart, with red and green diced hose. The blue Glengarry bonnet with a blackcock's feather was replaced in 1928 by a feather bonnet, with a blue and red hackle, by command of King George V, who also presented the bonnets.

The figure of the Pipe-Major of the Irish Guards has been included to complete the group of musicians of the Foot Guards although full dress for pipers of the Irish Guards was not issued until after the Great War, in 1921. Pipers were not introduced in the regiment until 1915. The pipe-major's doublet has bars of black laced edged with silver cord across the fronts, arranged in the Irish Guards' groups of four. The pipers do not have this cord. The gauntlet cuffs also have loops of black lace. The Pipe-Major wears the traditional Irish saffron kilt with a green cloak. The head-dress is the Irish 'cawbeen' with a St. Patrick's blue cut feather hackle. No sporran is worn in the Irish Guards. Dark green stockings are worn instead of diced hose by all pipers of the regiment.

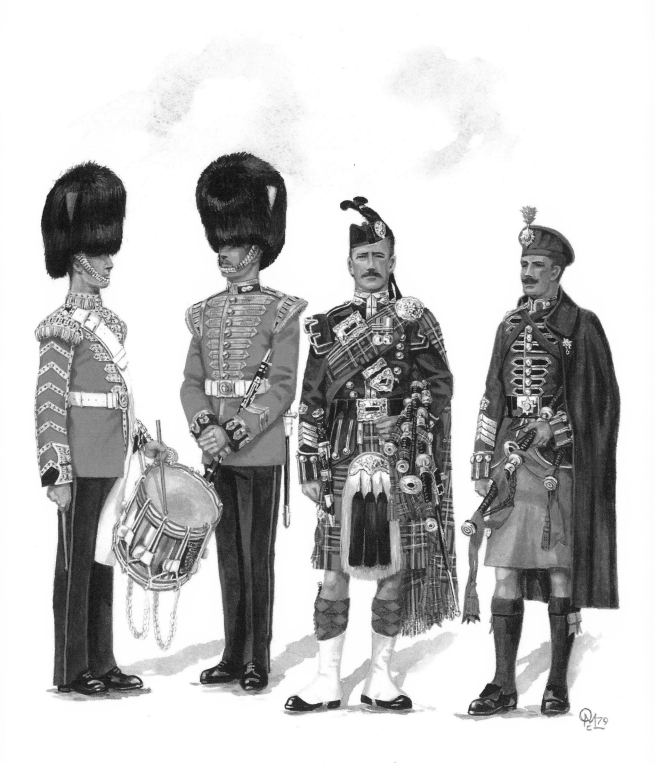

Drummer – Coldstream Guards
Musician – Grenadier Guards
Pipe-Major – Scots Guard
Pipe-Major – Irish Guards

The sergeant of the Coldstream Guards wears the Atholl grey greatcoat worn throughout the Foot Guards, the officers' pattern being double-breasted. The rank chevrons of a non-commissioned officer are worn above the cuff on the right sleeve. The peak of a sergeant's forage cap is bound with bands of brass, denoting rank, and in the case of the Coldstream Guards the cap band is white.

The Regimental Sergeant-Major of the Irish Guards has a green cap band and the peak of his forage cap is embroidered in gold. The tunic like that of a colour-sergeant is ornamented with gold lace and the badge of rank is the Royal Arms, embroidered in gold and colours on a black ground, and worn on the upper part of the right sleeve. Regimental Sergeant-Majors wear a hooked-up sword. All warrant officers of this rank in the Foot Guards wear this uniform, the only differences being in the spacing of the buttons and the colour of the cap band.

The lance-corporal of the Grenadiers shows the white serge shell jacket worn by other ranks up to and including the rank of sergeant in drill order throughout the Foot Guards. The buttons of the shell jacket were evenly spaced in all regiments and not grouped according to regimental custom. The rank chevrons, there being two for a lance-corporal in the Guards, were of white worsted lace, edged with blue on a scarlet ground. The drill jacket (also worn in Highland regiments) was not restored after the Great War. The cap band of the forage cap is scarlet in the Grenadier Guards.

The officer of the Scots Guards shows the frock coat worn by all officers of the Guards on drill parades and other special duties. The frock coat has bars of black mohair lace across the fronts and the collar and cuffs are decorated with similar braid, and complicated designs in black tracing braid. In this undress uniform, the crimson silk net sash is worn, with white buff leather sword slings and knot. The officer being an ensign wears trousers and not overalls. The figure shows the red, white and blue diced cap band worn by all ranks in the Scots Guards, officers in the other regiments having black lace. In the Scots Guards no cap strap is worn. The origin of this distinction is obscure, but it is believed that it may have been felt that a cap strap would disrupt the symmetry of the dicing. The peaks of officers' forage caps are embroidered in gold, the Guardsmen having a single band of brass.

Sergeant – Coldstream Guards
Regimental Sergeant-Major – Irish Guards
Lance-Corporal – Grenadier Guards
Officer – Scots Guards

5
The Infantry of the Line

The uniforms of the Infantry of the Line are dealt with in five groups, the first being the regiments wearing the universal pattern of cloth helmet. The other groups are the Fusiliers, the Scottish Lowland and Highland regiments, and the Rifles.

The officer of the Buffs wears the standard tunic of an officer of the Line, other than Scottish regiments and Rifles. The front peaks of officers' helmets were pointed and bound in gilt. The buff facings gave the regiment its name and date from 1667, although the colour at that time was variously described as 'flesh' or 'ash-coloured'. At the time of the Cardwell reforms in 1881 a new system was introduced giving English and Welsh regiments white facings, the Scottish yellow, and the Irish green, Royal regiments having blue. By 1914 however, many regiments had been permitted to revert to their old facings.

The sergeant of the Somersetshire Light Infantry shows the other ranks' tunic and helmet, the front peak of the latter being rounded and bound in leather. In Light Infantry regiments the helmets were covered in green instead of blue cloth. In the Somerset Light Infantry sergeants and officers tied their sashes on the right side instead of on the left. It is believed that this custom may have been a distinction granted by the Duke of Cumberland at the battle of Culloden in 1746, but the relevant records have been lost. The custom was however officially recognized for warrant officers and sergeants in 1865, and was approved for officers by King George V in 1931.

The drummer of the East Lancashire Regiment shows the standard drummer's lace and wings, the lace being white worsted with small red crowns. There is also twisted red and white cord at the bottom of the collar and edging the pointed cuffs. The figure is described as a drummer although he carries a bugle, the title 'bugler' being confined to Rifle regiments.

The officer of the South Staffordshire Regiment shows the blue frock coat worn in barracks or on special duty such as courts martial. The cap band of the forage cap was black lace except in Royal regiments which had scarlet bands. The crimson silk net sash and gold laced sword slings of full dress were worn in this order, which was also worn by bandmasters. The badge of both Staffordshire regiments was the 'Stafford' knot and dates from 1782 when the association of both regiments with the County of Stafford began at the King's command. The knot was a personal cognizance of the Earls of Stafford in the 15th century.

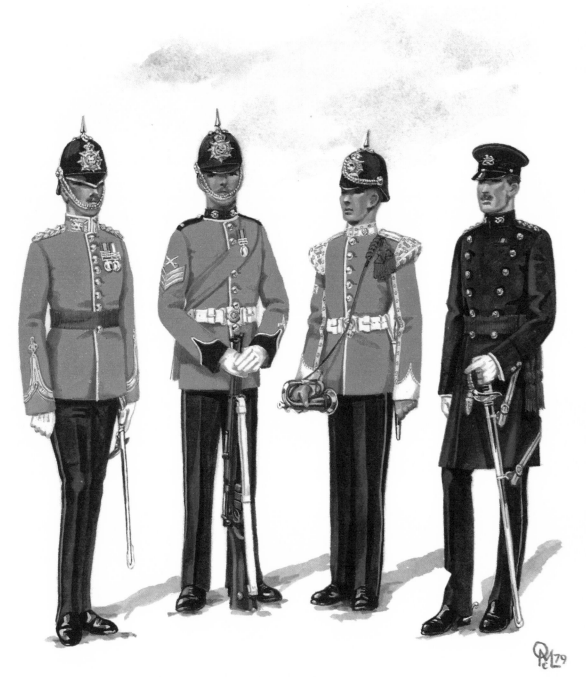

Officer – The Buffs (East Kent Regiment)
Sergeant – Prince Albert's Somersetshire Light Infantry
Drummer – East Lancashire Regiment
Officer – South Staffordshire Regiment

The officer of the 5th Northumberland Fusiliers is in mounted full dress with which pantaloons and knee boots were worn instead of overalls and Wellington boots. The facings of this regiment are described as 'Gosling' green, a colour which the regiment was permitted to retain when created a 'Royal' regiment in 1935. The origin of this description of the colour is not known. It has been conjectured that the French had a vulgar name for the faded facings of the regiment at the time of the Peninsular War, from which the present description derives. However green facings have been worn by the 5th for some three hundred years. The officer's head-dress was a bearskin cap. The 'Fusilier' cap of the other ranks being made of racoon skin, in a different shape. All ranks wore a grenade badge on the front of the head-dress. The colour of the plume, red over white in the 5th, together with the facings, distinguished the regiments.

The fusilier of the Royal Welch Fusiliers shows the back view of the other ranks' tunic in the Line, and the unique distinction of this regiment in the 'flash', a bow of black silk ribbons sewn to the back of the collar. The flash dates from 1805, when pigtails were abolished and with them the black bag which was used to protect the scarlet of the coat from the grease and powder of the pigtail. The Royal Welch Fusiliers were at sea at the time so they were the last regiment to wear the pigtail. To commemorate this fact, the regiment obtained the privilege of wearing the flash, a distinction which has been retained until the present day.

The bandsman of the Lancashire Fusiliers shows the standard tunic of a bandsman, which has the usual musician's wings trimmed with white braid. There was also white piping in the back seams. Bandsmen carried a music card case on a white buff leather belt. In the Lancashire Fusiliers no plume was worn in the Fusilier cap but a yellow hackle was worn by the regiment in the tropical helmet when abroad.

The officer of the Royal Irish Fusiliers shows the back view of an officer's tunic, with the pointed flaps on the skirts, and the gold laced sword slings with a crimson stripe in the centre. A distinction of this regiment was the custom of wearing two collar badges (a custom shared with Seaforth Highlanders). The first badge is a grenade, worn by all Fusiliers and the second is the coronet of H.R.H. the Princess Victoria. The double badge dates from the amalgamation of the 87th Royal Irish Fusiliers with the 89th (Princess Victoria's) at the time of the Cardwell reforms of 1881, but the coronet replaced the original badge of the Princess's monogram about 1890.

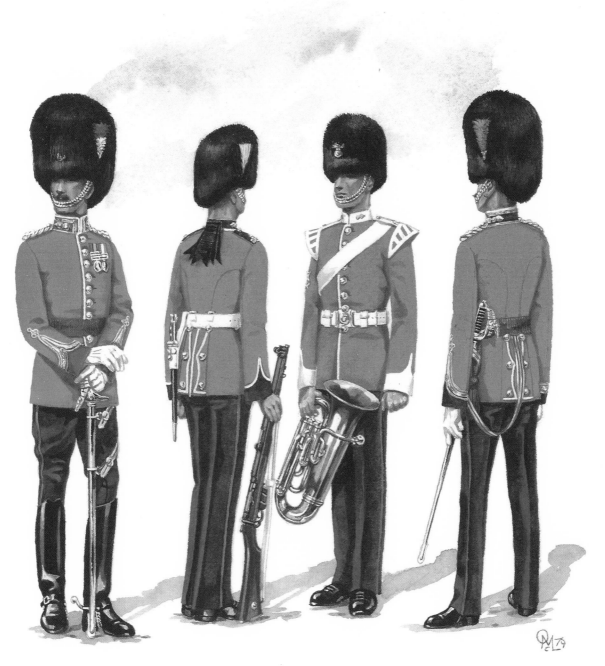

FUSILIERS
(Except the Royal Scots Fusiliers)

Officer – 5th Northumberland Fusiliers Bandsman – Lancashire Fusiliers
Fusilier – Royal Welch Fusiliers Officer – Royal Irish Fusiliers

*A*ll Lowland regiments wore the doublet, with gauntlet cuffs and 'Inverness' skirt flaps, and trews of the regimental tartan. The Colour-Sergeant of the Royal Scots Fusiliers wears the Fusilier cap with grenade badge and trews of the '42nd' or Government tartan. On his right sleeve he wears the three sergeant's chevrons with crossed flags and a crown above. Like all sergeants of the Line he wears a red sash over the right shoulder and white leather gloves.

In the Royal Scots the head-dress was the diced Kilmarnock bonnet with a blackcock's feather under the badge. The scarlet doublet was the same for all officers in both Lowland and Highland regiments, except in the Cameronians, the facings only being different. Regiments with blue facings showed a thin edge of blue above the gold lace on the cuffs, the other regiments having white piping. Officers in Lowland regiments wore strapped trews with Wellington boots, the tartan of the Royal Scots being the Hunting Stewart. All officers of Scottish regiments, again with the exception of the Cameronians, wore a white leather shoulder belt with a plate bearing regimental devices, with slings for the claymore or Highland broadsword. They also wore a crimson silk net sash over the left shoulder, (unlike officers of the Line who wore their sash around the waist) and a gold laced waistbelt. The badge of the Royal Scots, the Star of the Order of the Thistle, was slightly different in design on the shoulder- and waist-plates.

The officer of the Cameronians shows the unique uniform of that regiment. The officer's doublet, although described as Rifle green was actually black with black lace on the collar and cuffs and loops of black braid on the cuffs and skirt flaps. Instead of a sash, officers wore a black patent leather shoulder belt and pouch, with the badge, whistle and chains in silver. The sword belt and slings were also of black patent leather with a silver waistplate. The sword was the Rifle pattern with a bar guard and a black leather sword knot. The most distinctive feature of the uniform was the Rifle green shako with black silk cord lines and a black ostrich feather plume with a vulture feather bottom. The trews were of the Douglas tartan.

The Regimental Sergeant-Major of the King's Own Scottish Borderers wears the Kilmarnock bonnet with blackcock's feather, and the Staff doublet which was trimmed with gold lace and gold braid loops on the cuffs and skirts. The Regimental Sergeant-Major also wore an officer's pattern crimson silk sash, but over the right shoulder. He carried a broadsword in white slings suspended from a white buff leather waist belt. The rank badge of the Royal Arms was embroidered in gold above the cuff of the right sleeve. The trews of the Kings Own Scottish Borderers are of the Leslie tartan.

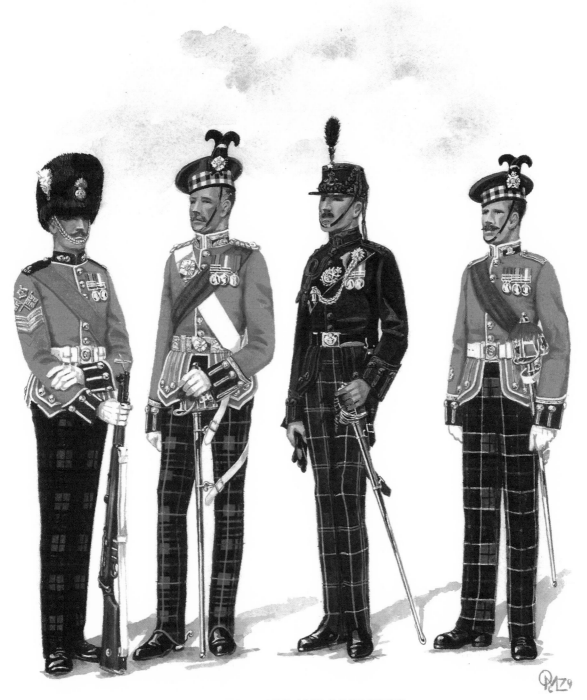

THE SCOTTISH LOWLAND REGIMENTS
(Including the Cameronians (Scottish Rifles))

Colour-Sergeant – Royal Scots Fusiliers
Officer – The Royal Scots (The Lothian Regiment)
Officer – The Cameronians (Scottish Rifles)
Regimental Sergeant-Major – The King's Own Scottish Borderers

ll the Highland regiments, except the Highland Light Infantry, wore the same uniform of feather bonnet, doublet, kilt and hose, but there are many differences in the accoutrements which form part of Highland dress and these have therefore been dealt with in some detail.

The officer of the Black Watch is in levée dress, in which order long hose with buckled shoes replaced hose tops and white spats. In the Black Watch the five sporran tassels were of gold bullion suspended from gold cords instead of the black horse-hair tassels worn in full dress. The kilt and shoulder plaid are of the very dark 42nd tartan from which it is said the regiment derives its title. On the right side of the officer's kilt there are two dark green silk bows and the garter flashes are worn cutting the centre dice of the hose. In the feather bonnet, which in the Black Watch has only four 'tails', is the red hackle of vulture feathers which has been a distinction of the regiment since 1795.

The Cameron Highlanders in levée dress wore the full length plaid and no sash. The officers' grey goat-hair sporran, with its six gold bullion tassels suspended from blue and gold cords, is unique, as is the dirk belt embroidered with a thistle design in gold and having an oval clasp, all the other regiments' waist-plates being rectangular. The Camerons were the only Highland regiment to wear red and green hose and their garter flashes are worn at the side of the leg. The tartan of the regiment is the Cameron of Erracht. Both officers carry the Highland basket hilted broadsword and wear dirks and sgian dubhs of regimental pattern with gilt mountings.

The drummer shows the drummer's doublet with its lace and wings and twisted red and white cord loops on the cuffs and flaps, and the white buff leather apron. The drummers' sporran, which was the same for all other ranks, is of black horse hair with two white tassels, and was worn pushed to one side. The drummer also wears a dirk on the right hip. The foot straps of the spats in the Camerons were black and the bugle strings were in the Royal colours of blue, red and yellow.

The sergeant of the Black Watch wears the same sporran as that of an officer in full dress, with a gilt top, the other ranks' top being of black leather. Sergeant's kilts had the same green silk bows on the kilt apron as the officers'. Like all sergeants in kilted Highland regiments, the sergeant wears a shoulder plaid fastened with a brooch bearing the regimental device. A peculiarity of the Black Watch is that the fronts of their spats are notched instead of being rounded as in the other regiments.

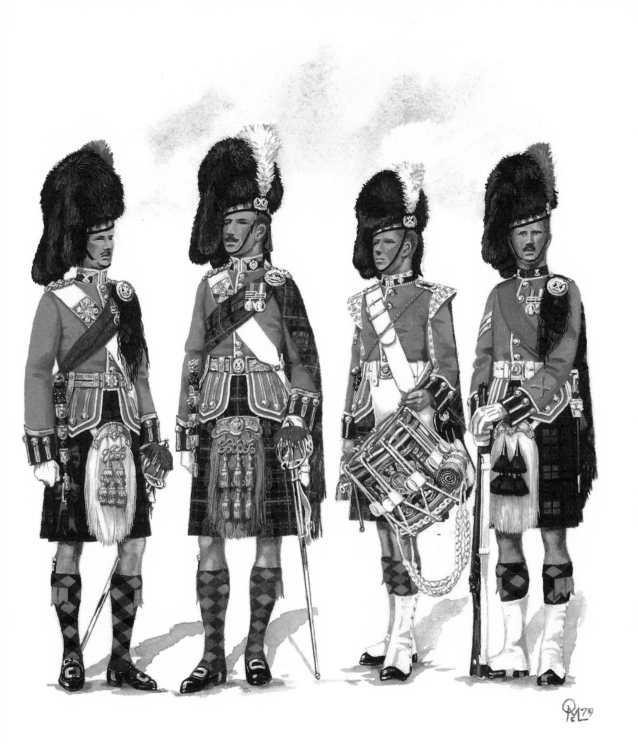

THE SCOTTISH HIGHLAND REGIMENTS

Officer – The Black Watch (Royal Highlanders) Drummer – The Queen's Own Cameron Highlanders

Officer – The Queen's Own Cameron Highlanders Sergeant – The Black Watch (Royal Highlanders)

The private illustrates the standard uniform of private soldiers in the kilted regiments, the Seaforths' facings being buff, the colour from which the regiment derives its secondary title. Other ranks wore a short belted plaid attached to the shoulder by a ribbon. The private's sporran had a black leather top bound in brass, whereas a sergeant's sporran had a brass top with brass cups for the tassels. The other ranks' feather bonnet was smaller than that of the officers, both having a white cut feather hackle. The number of 'tails' was five in this regiment.

The officer of the Seaforths shows the full dress review order with spats and hose tops. The garter flashes are peculiar being single with two folds, worn at the side. The regiment had the distinction of wearing two collar badges, one being the Assaye elephant and the other the cypher 'F' of Frederic, Duke of Albany. The officer's sporran had six gold bullion tassels suspended from gold and crimson cords, and the regimental tartan was the Mackenzie.

The officer of the Highland Light Infantry shows the unique dress worn by the regiment. The head-dress was a dark green shako with a diced border and a green tuft, worn with black lines looped on the left breast. The Highland doublet was worn with tartan trews, those of the officers being strapped. The wearing of trews dates from 1807 when the regiment returned, without uniform, from the unsuccessful expedition to Buenos Aires in 1806, and tartan trews were issued as a temporary measure. On conversion to Light Infantry in 1809, some items of Highland dress were discarded and during the Peninsular War grey 'service' trousers became the standard wear. In 1834 a more Highland look was restored, but trews were retained as being more suitable for a Light Infantry regiment, trews in any case being regarded as part of Highland dress. Officers of the regiment wore the full length plaid and carried a dirk. The broadsword had a cross-bar hilt except for levées when the normal basket guard was adopted. The device on the shako included the Assaye elephant.

The piper of the Camerons wears the green doublet worn by all pipers in Highland regiments, which had wings trimmed with white braid and white piping in the back seams. Pipe-Majors' doublets were ornamented with gold lace. Pipers wore a shoulder belt and dirk belt those of the Camerons having special patterns of buckles and an oval belt clasp. Pipers wore the Glengarry bonnet (except in the Black Watch, who had a feather bonnet) and a distinction of the Camerons was the eagle's feather instead of the blackcock's feather worn in the other regiments. Their pipe bags were green as was one ribbon on the pipes the other being of the Cameron of Erracht tartan. Their sporrans were grey horse hair with white tassels. Like all pipers, this piper wears the full long plaid, his brooch being a plain circle.

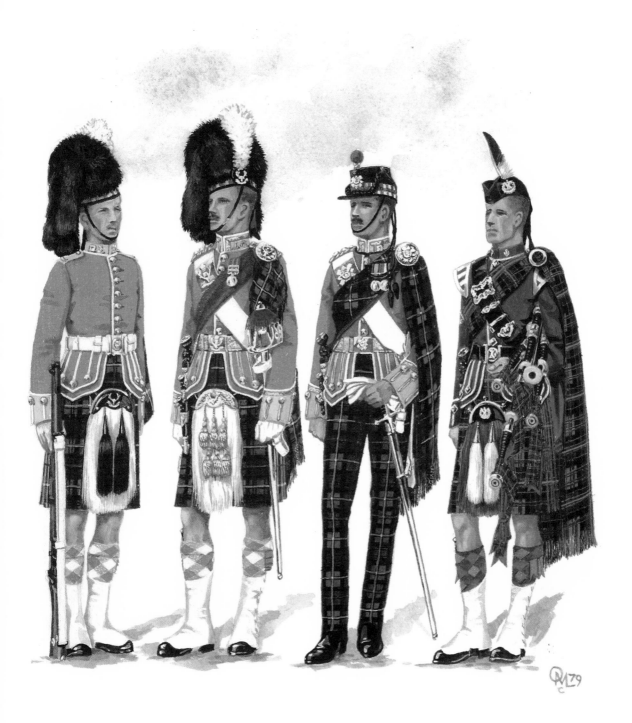

Private – Seaforth Highlanders (Ross-shire Buffs, The Duke of Albany's)
Officer – Seaforth Highlanders (Ross-shire Buffs, the Duke of Albany's)
Officer – The Highland Light Infantry
Piper – The Queen's Own Cameron Highlanders

The bandsman's doublet shows the wings, and the white piping in the seams, of the musician, and he wears a full length plaid. Bandsmen wore a dirk on the right hip and a music card case. A distinction of the band of the Gordons was the red and white hackle in the feather bonnet.

The officer of the Gordons shows the black line in the lace and the gold shoulder cords, and also the black buttons and foot straps of the spats. These distinctions are in mourning for General Sir John Moore who was killed at the battle of Corunna in 1811. Officers of the Gordon Highlanders carried his coffin at the funeral, while pipers of the regiment played a lament. In the Gordons, officers wore the shoulder belt under the dirk belt, which had black lines separating the gold embroidery, and the silver mountings on the dirk and sgian dubh were upright instead of being sloping as in the other regiments. The garter flashes of the Gordons are double, the upper half being looped, and the regimental tartan is of course the Gordon. Officers in this regiment had ten buttons on the spats the other ranks having the usual eight, and the buttons and foot straps were black.

The officer of the Argylls illustrates the levée dress in which order a special sporran with a five sided enamelled top, edged with gilt and bearing the regiment's devices, was worn. There were five gold tassels on this sporran. A special distinction in the Argylls is the green embroidered panel with green silk bows on the right side of the kilt apron. Officers of the regiment wore the shoulder belt over the sash instead of beneath it as in the other regiments. The feather bonnet had six 'tails', and the garter flashes were worn cutting the centre dice in front. The tartan was the same sett as that of the Black Watch, sometimes referred to as the 'Government' tartan, but with a lighter shade of green.

The sergeant of the Argylls shows the white serge shell jacket worn in drill order by officers and other ranks in all the Highland regiments. The Glengarry bonnet was worn in this order, that of the Argylls having a red and white diced border. (The Seaforths and Gordons had red white and black dicing on their bonnets, the other two Highland regiments having plain blue Glengarries). Sergeants of the Argylls wear the same panel and bows on their kilts as the officers. They wore a distinctive sporran of fur with a badger's head top and six white horsehair tassels in gilt cups. The sporran, which dates from 1829, was also worn by officers in review order. The sporrans of other ranks were black horse hair with six short white tassels.

In drill order only the ribbons of medals were worn.

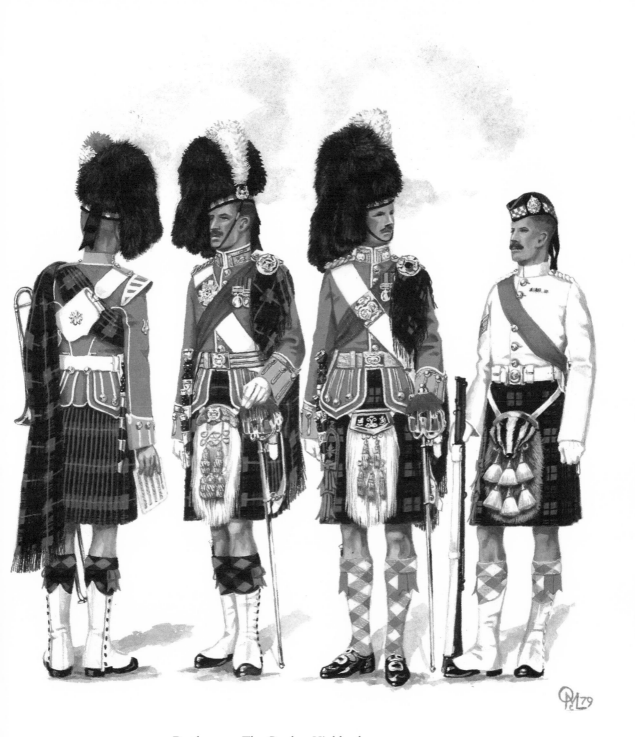

Bandsman – The Gordon Highlanders
Officer – The Gordon Highlanders
Officer – The Argyll and Sutherland Highlanders
Sergeant – The Argyll and Sutherland Highlanders

When the authorities first equipped certain regiments with a new weapon having a rifled bore, a dark green was selected for the uniform because this colour was considered to be more suitable than scarlet for the skirmishing and sharp-shooting duties on which units armed with the new rifle were to be employed. The first regiment so equipped and dressed was the 95th Foot, later to become the Rifle Brigade, and this corps is the only infantry regiment never to have worn a scarlet coat.

The distinctive green uniforms of Rifle regiments, who take the left of the line on parades, has given rise to the saying: 'There is always to be seen a little strip of green at the end of the Thin Red Line'.

The sergeant of the Rifle Brigade shows the uniform of the other ranks in the Rifle regiments, the buttons and accoutrements being black, and the waist belt having a snake hook fastening. The head-dress was a busby of black seal skin with a plaited cord in front and a short horse-hair plume. The rank chevrons were black worsted edged with gold cord. The rifle sling in Rifle regiments was worn hanging loose.

The officer of the King's Royal Rifle Corps (the famous 'Sixtieth') illustrates the special pattern of tunic, which was similar to that of a Hussar, with black silk cords and loops across the fronts and 'Austrian' knots above the cuffs. It is said that this pattern of tunic derives from a regiment of Black Brunswick Hussars that visited Great Britain in the early 19th century and caused a great sensation. The officers' busby was of black Persian lambskin with black silk cord lines, looped on the chest. The officers' plume was of ostrich feathers, scarlet in the 60th, with a vulture feather bottom. Officers wore a black patent leather shoulder belt and pouch, with silver devices and a whistle and chains. In the 60th the facings were of scarlet cloth. The sword was the three-bar hilted Rifle pattern and was worn with patent leather slings and sword knot.

The bugler of the 60th shows the special distinctions of buglers whose tunics were decorated with scarlet and black twisted cord on the collar, cuffs and back seams, and also on the musician's wings. The other ranks of the 60th had scarlet collars, the cuffs being green. In Rifle regiments the bugles are silver instead of the normal copper.

The officer of the Royal Irish Rifles wears a dark green tunic, known as the 'toggle' tunic, with very dark green cording, and the overalls have a single black mohair stripe. The plume was black with a green vulture feather bottom. Officers' spurs in Rifle regiments were straight instead of being swan-necked and black leather gloves were worn.

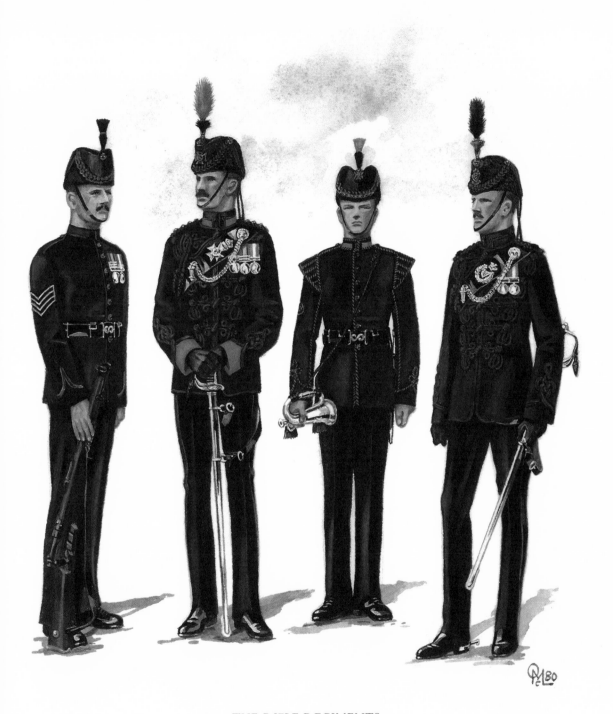

THE RIFLE REGIMENTS
(Except the Cameronians (Scottish Rifles))

Sergeant – The Rifle Brigade (The Prince
 Consort's Own)
Officer – The King's Royal Rifle Corps

Bugler – The King's Royal Rifle Corps
Officer – The Royal Irish Rifles

The uniform of the Corps and Departments, which included the Army Ordnance Corps, the Army Pay Corps, the Army Veterinary Corps and the Corps of Military Police, as well as the two Corps illustrated, was basically the same. The universal blue cloth helmet was worn, with a blue tunic and trousers or overalls, the tunics having different coloured facings. There were however several distinctions which are dealt with below. The Army Service Corps was designated 'Royal' after the Great War.

The driver of the Army Service Corps shows the standard dress of other ranks. He wears a girdle in the Corps colours instead of a waistbelt, and there are double white stripes on his pantaloons. The cuffs of the tunic are decorated with a trefoil and curl in white cord and the helmet has a ball in a leaf cup on top. Drivers wore a leg guard on the right leg to protect the leg from contact with the pole of the vehicle when driving.

The officers' tunic in the Army Service Corps unlike that of the other ranks' has white cuffs, decorated with an 'Austrian' knot in gold cord, as well as a white collar. The fronts and skirts of the tunic are edged with white cloth. The shoulder belt, girdle and sword slings had a blue stripe in the centre of the gold lace. The officers' sword was of special pattern with a half basket guard and a slightly curved blade and the sword knot was of gold cord with a blue line worked in it.

The staff-sergeant of the Royal Army Medical Corps shows the special pattern of helmet plate, which has a Red Cross in the centre of the ring. The collar and cuffs of dull cherry cloth were edged with gold lace, the fronts of the tunic being edged with cloth of the same colour. The stripes on the overalls were also dull cherry, with two black welts. The staff-sergeant's rank badge consisted of a crown and a Red Cross in a gold circle above the three chevrons, and he carried a sword hooked up on a white buff leather sword belt.

A distinction of the officers' tunic in the Royal Army Medical Corp was the gauntlet shaped cuffs, the origin of which is obscure, instead of the pointed cuffs of the other Corps. The shoulder belt, sword belt, and slings were of black leather decorated with stripes of gold embroidery. The helmet had a gilt ball in a leaf cup on top, as did the Army Veterinary Corps, the remaining Corps having a spike.

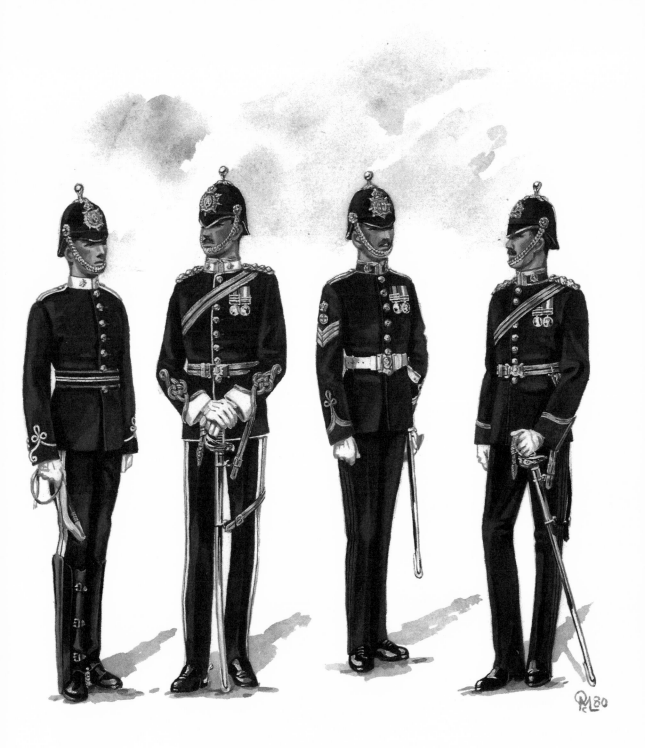

Driver – Army Service Corps
Officer – Army Service Corps
Staff-Sergeant – Royal Army Medical Corps
Officer – Royal Army Medical Corps

Before 1914, when a considerable part of the British Army was serving abroad in stations where climatic conditions prohibited the wearing of full dress, a special form of dress uniform made of white drill was authorized. The head-dress in this uniform was the white tropical Wolseley helmet which, in the case of officers, usually had a spike (or a ball in a leaf cup, according to unit) and a chin chain. These items were sometimes omitted by the other ranks but the wearing of spikes and chains was the subject of some variation. Certain regimental distinctions were however worn in the helmet although cap badges were not worn by all regiments. Full dress accoutrements were worn with the white uniform, and in some stations, where the climate permitted, full dress overalls or trousers were sometimes worn with a white jacket. Gloves were not worn with tropical uniform.

The officer of the Rifle Brigade shows the Rifle green pugarree worn on the helmet with the regimental badge in silver. The spike and chain are bronze, as opposed to gilt, as was usual in a Rifle regiment, and the spike has a domed base. Black horn buttons were worn by this regiment.

The officer of the 18th Hussars wears full dress overalls and the buttons on his jacket are full dome burnished. In the cavalry the base of the spike was acanthus leaves and the spike was higher.

The sergeant of the Royal Fusiliers illustrates the standard tropical dress uniform of an infantry soldier. In this regiment a hackle of white bristles was worn on the right side of the helmet, but there was no spike or chin chain. A brown leather waistbelt with a prong buckle, and a brown leather rifle sling were worn with this uniform.

The private of the Black Watch wears a scarlet serge frock with the blue regimental facings and the rounded fronts, gauntlet cuffs, and side pocket flaps peculiar to Scottish regiments. This scarlet jacket was in fact the last form of undress uniform issued to other ranks, being a modification of the undress frock authorized in 1881. This garment was abolished in 1902 except for use abroad where it was worn instead of the full dress tunic. Officers however wore their full dress tunics when this frock was worn by the other ranks. Highland regiments in tropical uniform continued to wear the kilt, sporran, and hose with spats, of full dress. In the Black Watch, the regiment's red hackle was worn in the helmet, but no other ornament, and again a brown leather waistbelt and rifle sling replaced the white buff leather belt and sling of full dress.

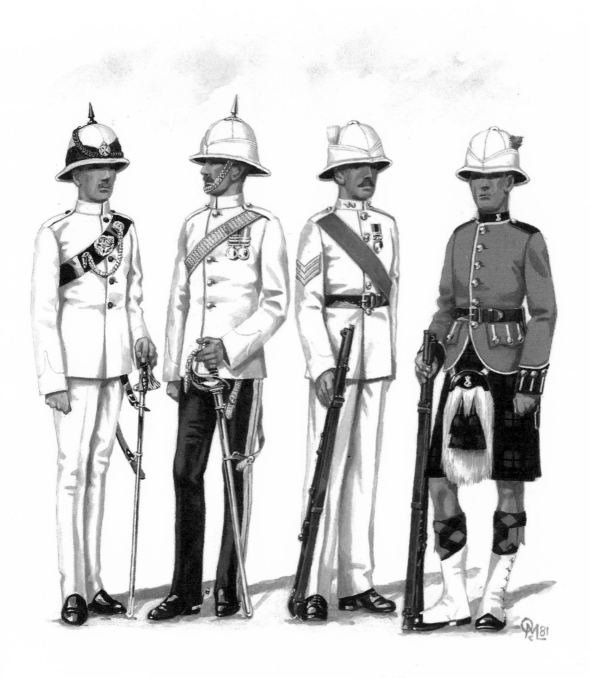

UNIFORM FOR SERVICE ABROAD

Officer – The Rifle Brigade (The Prince
 Consort's Own)
Officer – 18th Hussars

Sergeant – The Royal Fusiliers (City of London
 Regiment)
Private – The Black Watch (Royal Highlanders)

*I*n the days when the Cavalry were still horsed, the ride of a regiment was always its drum horse, which led it on parade. These horses were usually of a different colour from the other horses, skewbalds or piebalds frequently being chosen. In the Royal Scots Greys, the drum horse was a black. A drum horse had to be carefully selected not only for its colour and points but also for its strength, the weight of the kettle drums and additional caparisoning being considerable. The drums were usually covered by banners, generally of the colour of the facings or busby bags of the regiment, which were embroidered with the regimental badge and other devices, and scrolls bearing the battle honours. In the case of Hussars and Lancers, who carried no regimental standard or guidon, the drum banners took the place of these emblems.

In addition to the banners a drum horse usually carried a shabraque embroidered with devices and battle honour scrolls, and also a throat plume. The headstall and breast collar were of special patterns ornamented with devices. Because of certain unique features, the drum horse of the 3rd Hussars has been selected to represent the drum horses of the cavalry of 1914.

In the 3rd Hussars no drum banners were carried. The silver kettle drums of the regiment were captured from the French at the battle of Dettingen by the then King's Own Dragoons. However, the original drums were destroyed in a fire and the present drums were bought by the officers to replace them. In commemoration of the battle of Dettingen the silver drums are never covered on parade. A further distinction of the 3rd Hussars is the silver collar, 3 inches high, worn by the drummer, which was presented in 1772 by Lady Southampton, wife of the then Colonel of the regiment. As well as the shabraque, a leopard skin with a scalloped edging of 'Garter' blue was worn in the 3rd Hussars. The drum horse of the regiment was traditionally a grey.

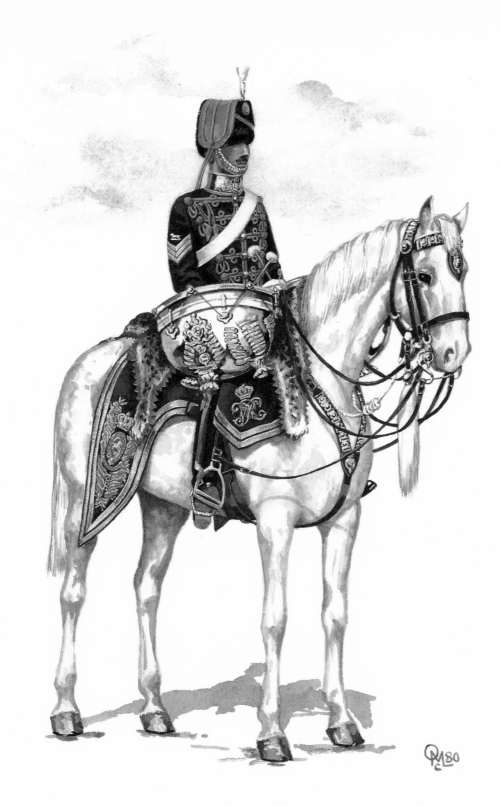

THE DRUM HORSES

Drum Horse – 3rd (The King's Own) Hussars

In a number of regiments the soldiers kept animals as pets or mascots and some of these were given the dignity of leading the regiment on parade. Among the most famous of these animals has been the goat of the Royal Welch Fusiliers. In this regiment, the goat, which is however never referred to as a mascot, is an essential part of the regiment, accompanying it wherever it goes. It is known for example that a goat was in action at the battle of Bunker's Hill in 1775. The first Royal goat was presented to the Royal Welch Fusiliers in 1884, the animal being selected from a herd started from a pair presented to Queen Victoria by the Shah of Persia. In more recent times, when no goat has been available from the Royal herd, Her Majesty Queen Elizabeth II has presented a goat from a wild herd in Wales.

The goat of the Royal Welch Fusiliers is led by a drummer with the title of Goat-Major, who wears the full dress uniform of a drummer with dress cords in the Royal colours. Each goat has its own head shield inscribed with the name of the Sovereign who has presented it. In the case of the First battalion, illustrated in the plate, the goat also carries a breast shield presented by the people of Lichfield in token of their regard for the battalion's services in the South African war. The horns of the goat have always been gilded but carry no silver points.

The other regimental mascot illustrated is the ram of the Sherwood Foresters, which has been named 'Derby' ever since a ram was first acquired at the siege of Kotah, during the Indian Mutiny operations. This remarkable animal accompanied the regiment throughout the campaign and was awarded the Indian Mutiny medal. A replica of this medal has been worn by the ram ever since. The ram was led by a private soldier, designated the Ram Orderly, who wore the standard full dress uniform of a private of the Line. The coat worn by the ram was embroidered with the regimental badge and scrolls bearing the battle honours, and the ram also carried a silver head shield.

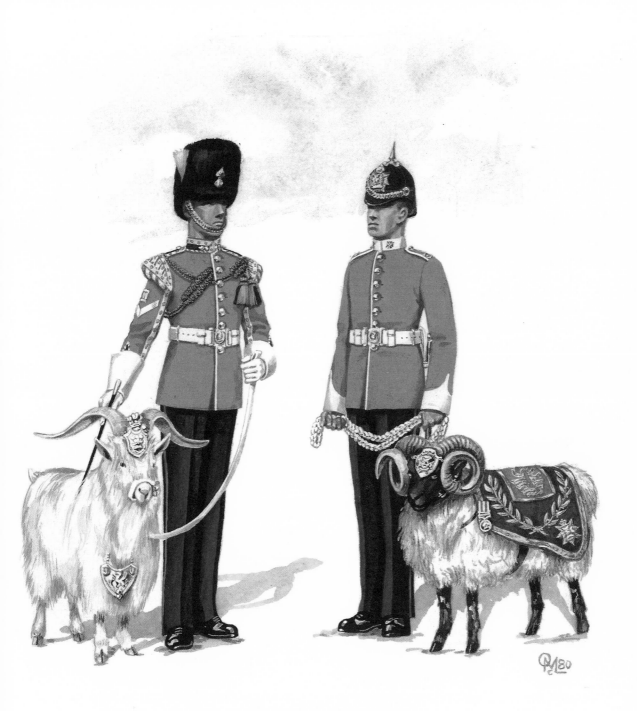

REGIMENTAL MASCOTS

Goat Major and Goat – The Royal Welch Fusiliers
Ram Orderly and Ram – The Sherwood Foresters (Notts and Derbyshire Regiment)

Although full dress was not again generally issued after the Great War it nevertheless remained an authorized order of dress, although applicable only to the Household troops and to certain officers, specially permitted by the War Office to wear it. Furthermore, the new Dress Regulations issued in 1934 stated, that 'the patterns of full dress head-dress authorized in Dress Regulations 1911 for those regiments and corps which are authorized in these (i.e. 1934) Regulations to wear the cloth helmet, will continue to be worn until a decision has been reached on the new pattern, which is still under consideration'. It is interesting to speculate on what that head-dress might have been had not the outbreak of the Second world War swept away full dress as a generall issue for all time.

However, as full dress uniform remained as an authorized dress between the wars, it has been thought appropriate to include in this record some of the uniforms authorized in 1934. The new Regulations catered for a number of changes arising from the amalgamations which took place in the Cavalry of the Line in 1922, but they also included details of uniforms designed for new corps which had been raised since 1914.

In the case of the Royal Artillery and Royal Engineers, the change of head-dress anticipated in the 1934 Regulations actually took place, the cloth helmet in each case being replaced by a busby. In the Royal Artillery this busby had a scarlet bag and a short white plume on the left side, while the Royal Engineers adopted a Garter blue busby bag and a white plume.

The new Royal Corps of Signals, formed after the Great War from the Royal Engineers, were given a similar tunic but with black facings and edges to the fronts, and a busby with a black bag and a red plume. The gold-laced shoulder belt and sword belt and slings had a black line in the centre. It is not known why a Royal Corps should not have been given the normal Royal blue facings, although it has been thought that the black might possibly have been an allusion to the black uniforms once worn by a signal battalion of the Royal Engineers.

Another new uniform was that designed for the Royal Tank Corps, which had its origins in the Great War. The tunic of blue cloth was similar to the tunics of other Corps, with black velvet facings and overalls with a single mohair stripe. Instead of a girdle or sword belt the new Corps had a black and gold net sash, with two gold stripes. The head-dress was the beret. The headgear adopted during the War as being more suitable than a cap for wearing inside a tank. Under the Corps badge was worn a short plume in the Corps colours of red, green and brown.

Finally, the raising of the Welsh Guards by command of King George V in 1915 necessitated the issue of full dress to the new regiment, the tunics having buttons in sets of five, and a white, and white plume being worn on the left side of the bearskin. Home service clothing was issued to musicians on St. David's day, 1916, but the rest of the regiment did not receive it until full dress was restored in 1920.

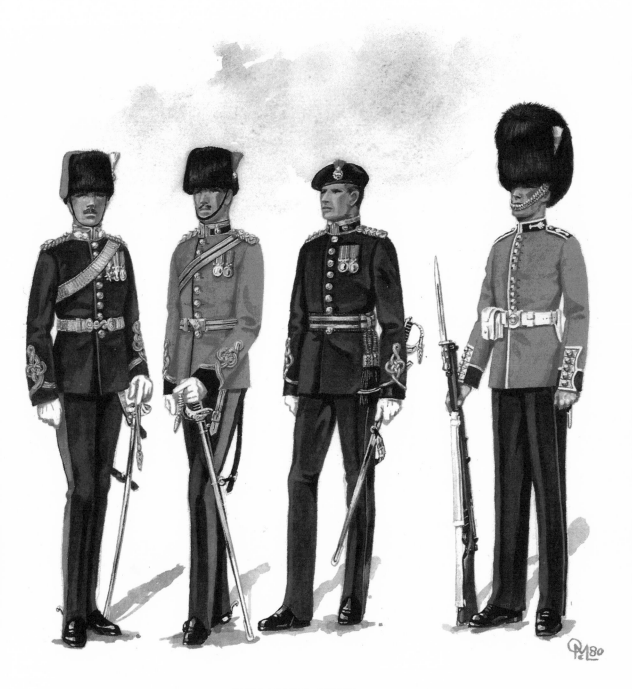

FULL DRESS AFTER 1914

Officer – Royal Artillery
Officer – Royal Corps of Signals

Officer – Royal Tank Corps
Guardsman – Welsh Guards

Conclusion

In the British Army of the 1980s there is no place for a dress uniform for every day wear. The clothing of the British soldier has to be designed to meet the conditions of modern mechanized warfare, and the high cost of weapons and equipment leaves nothing to spare for the provision of elaborate uniforms for only occasional use. Except for the Household Division, therefore, the khaki service dress of 1914 has to do for ceremonial purposes, the general issue of the new Number 1 Dress having been abandoned.

Nevertheless, regiments continue to cling to their traditional uniforms. Many bands can still be seen in the old full dress and on special occasions even orderlies and markers are similarly dressed in some regiments. This uniform has of course to be provided at considerable expense by the regiments themselves.

However, the days are gone in which the choice of a particular fur for a head-dress, or feathers for a plume, were matters of import for serious consideration. No longer is the manufacture of intricate regimental devices a task for the craftsman in silver, or the embroidery expert. Nor do gold lacemen have to weave some seventy or more patterns of regimental lace any more.

But the numerous details of the old full dress have been handed down over the long years of the life of the British Army, and it follows that in them are entwined much of the history of that Army. Those who wore full dress in the course of their daily duties formed Great Britain's 'Great Little Army' of 1914, and this record of their uniform, and the histories attached thereto, may perhaps serve to ensure that 'their glory shall not be blotted out'.

Bibliography

Adam, F *The Clans, Septs and Regiments of the Scottish Highlands,* Edinburgh & London, W & A K Johnston Ltd, 2nd edition 1924

Bowling, A H *British Hussar Regiments 1805–1914,* New Malden, Almark Publishing Co Ltd, 1972

Bowling, A H *The Foot Guards Regiment 1880–1914,* New Malden, Almark Publishing Co Ltd, 1972

Bowling, A H *British Infantry Regiments 1660–1914,* Edgware, Almark Publishing Co Ltd, 1970

Bowling, A H *Scottish Regiments and Uniforms 1660–1914,* New Malden, Almark Publishing Co Ltd, 1970

Braddon, R *All the Queen's Men – The Household Cavalry and the Brigade of Guards,* London, Hamish Hamilton, 1977

Cassin-Scott, D and Fabb, J *Military Bands and their Uniforms,* Poole, Blandford Press, 1978

Clements, D *The Victorian Army in Photographs,* Newton Abbott, David & Charles Ltd, 1975

Dress Regulations for the Officers of the Army 1900, Newton Abbott, David & Charles Ltd, 1970

Dress Regulations for the Army 1934, London, H M Stationery Office, 1934

Grant, C *Royal Scots Greys,* Reading, Osprey Publishing Ltd, 1972

Grant, C *The Black Watch,* Reading, Osprey Publishing Ltd, 1971

Innes of Lerney, T *The Tartans and Clans and Families of Scotland,* Edinburgh & London, W & A K Johnston Ltd, 1950

Joslin, E C *Standard Catalogue of British Orders, Decorations and Medals,* London, Spink & Son Ltd, 1969

Kemp, A *15th The King's Hussars: Dress and Appointment 1759–1914,* New Malden, Almark Publishing Co Ltd, 1972

Legge-Bourke, H *The Household Cavalry on Ceremonial Occasions*, London, Macdonald & Co Ltd, 1952

Legge-Bourke, H *The Brigade of Guards on Ceremonial Occasions*, London, Macdonald & Co Ltd, 1952

McElwee, W *Argyll and Sutherland Highlanders*, Reading, Osprey Publishing Ltd, 1972

Manser, R *The Household Cavalry Regiment*, London, Almark Publishing Co Ltd, 1975

Mollo, B *The British Army from Old Photographs*, London, J M Dent & Sons Ltd, 1975

National Army Museum *The Army in India 1850–1914*, London, Hutchinson & Co Ltd, 1968

Paget, J *The Story of the Guards*, London, Osprey Publishing Ltd, 1976

Robinson, C *Navy and Army Illustrated Magazine* Vols I & II, London, Hudson & Kearns, 1895–6

Simkin, P *The Guards – Changing of the Guards, Trooping the Colour*, London, The Macmillan Commercial Promotions Ltd, 1972

Society for Army Historical Research *Regimental Histories Journal*, Aldershot, National Army Museum

Stadden, C *The Life Guards – Dress and Appointments 1660–1914*, New Malden, Almark Publishing Co Ltd, 1971

Talbot-Booth, E G *The British Army, its History, Customs, Traditions and Uniform*, London, Sampson Low, Marston & Co Ltd, 1936

Thorburn, W A *Uniform of the Scottish Infantry 1740–1900*, Edinburgh, H M Stationery Office, 1970

Wilkinson-Latham, C *The Royal Green Jackets*, Reading, Osprey Publishing Ltd, 1975

Wilkinson-Latham, R *Scottish Military Uniforms*, Newton Abbott, David & Charles Ltd, 1975

Wilkinson-Latham, R & C *Cavalry Uniforms*, London, Blandford Press, 1969

Wilkinson-Latham, R & C *Infantry Uniforms*, (book 2) including Artillery and other Supporting Corps of Britain, London, Blandford Press, 1970

Wilkinson Sword Ltd *Swords*, London, Wilkinson Sword Ltd, 1973

Glossary

AIGUILLETTE

A plaited cord attached to the shoulder ending in metal tags. It is the distinguishing mark of officers serving on the Staff of the Army, and those holding personal appointments (e.g. aide-de-camp). In the Household Cavalry it is worn by all officers in full dress and by Non-Commissioned officers instead of chevrons.

BRIDOON REIN

The rein attached to the snaffle ring of a military bridle.

CARTOUCHE

A small pouch attached to the shoulder belts of the cavalry.

CUIRASS

Armour consisting of front and back plates held together by straps and shoulder 'scales' worn in the Household Cavalry.

GUIDON

A cavalry regimental flag with a swallow-tailed fly.

OVERALLS

Tightly fitting trousers strapped under the sole of the Wellington boot. Worn by cavalrymen when in a dismounted order of dress (and by Infantry officers).

PUGGAREE

The folded cloth wound round the head as a head-dress in India. The same term is used for the folds of cloth on the Wolsey helmet.

SHABRAQUE

A decorative saddle cloth worn under the saddle.